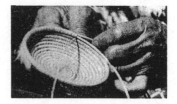

Mabel McKay

Mabel McKay

WEAVING THE DREAM

Greg Sarris

With a New Preface

UNIVERSITY OF CALIFORNIA PRESS BERKELEY LOS ANGELES LONDON

University of California Press, one of the most distinguished university presses in the United States, enriches lives around the world by advancing scholarship in the humanities, social sciences, and natural sciences. Its activities are supported by the UC Press Foundation and by philanthropic contributions from individuals and institutions. For more information, visit www.ucpress.edu.

University of California Press
Berkeley and Los Angeles, California

University of California Press, Ltd.
London, England

ISBN: 978-0-520-27588-1

The Library of Congress has catalogued an earlier edition as follows:

Library of Congress Cataloging-in-Publication Data

Sarris, Greg.
 Mabel McKay: weaving the
 dream / Greg Sarris.
 p. cm.—(Portraits of American genius; 1)
 ISBN 978-0-520-20968-8
 1. McKay, Mabel, 1907–1993. 2. Pomo
women—Biography. 3. Pomo Indians—Basket
making. 4. Pomo Indians—Religion and
mythology. I. Title. II. Series.
 E99.P65S29 1994
 973'.04975—dc20 93-38188
 CIP

Manufactured in the United States of America

22 21 20 19 18 17 16 15 14 13
10 9 8 7 6 5 4 3 2 1

In keeping with a commitment to support environmentally responsible and sustainable printing practices, UC Press has printed this book on Rolland Enviro100, a 100% post-consumer fiber paper that is FSC certified, deinked, processed chlorine-free, and manufactured with renewable biogas energy. It is acid-free and EcoLogo certified.

The strip design used throughout the book is
drawn from Mabel's mother's last basket, which
Mabel finished in 1971. (By permission of Pacific
Western Traders)

I was born in Nice, Lake County, California. 1907, January 12. My mother, Daisy Hansen. My father, Yanta Boone. Grandma raised me. Her name, Sarah Taylor. I followed everywhere with her. I marry once in Sulphur Bank. Second time I marry Charlie McKay. We live in Lake County, then Ukiah, then Santa Rosa. I weave baskets, and show them different places. Have son, Marshall. Now grandkids, too. My tribe, Pomo.

There, how's that? That's how I can tell my life for the white people's way. Is that what you want? It's more, my life. It's not only the one thing. It's many. You have to listen. You have to know me to know what I'm talking about.

MABEL MCKAY

CONTENTS

She turned to me, took a moment to make sure she had my attention, then she answered plainly, "You live the best way you know how, what else?"

As I write today, some twenty-five years after that autumn afternoon with Mabel, the signs of global warming are everywhere; daily we hear frightening prognostics from the scientific community regarding global warming worldwide. The United States is experiencing its worst drought since the 1930s. Lake County, where Mabel was born, is suffering two major fires, and smoke and ashes from those fires can be seen from my home on Sonoma Mountain, in Sonoma County fifty miles away. Among the Pomo Indians of Northern California—Mabel was the last surviving member of the Cache Creek Pomo Nation—there were many prophets, locally often referred to as Dreamers, and Mabel McKay was certainly one of them. According to many people, she was the last of them. Her great-uncle Richard Taylor saw "roads into the sky, people going to the moon." Essie Parrish, the late Kashaya Pomo Dreamer, seeing pitch suddenly dripping from one of her baskets in the 1950s, predicted "a horrible sickness thirty years hence, first seen in young men then in multitudes."

Like Mrs. Parrish, Mabel McKay was also a medicine woman, as it would turn out, the last of the sucking doctors among the Pomo, doctors who extract pain and disease through sucking. She was a world-renowned basketweaver—the Pomo are considered among the finest weavers anywhere, and Mabel was often thought of as the best among them. But what remains for me, and I think for many readers of this book over the years, isn't only the remarkable enough attributes and accomplishments of Mabel's life, but her uncanny, if not at times jarring, ability—in conversation, in stories, in responses to questions—to open up the world such that we come to see ourselves fully in the world with her, and long

after. We not only get glimpses into her worldview but, in doing so, become more conscious of our own. What is she then, in my experience of her, in the pages of this book, but the best of life teachers, whose stories and lessons become indelible in memory?

To illustrate Mabel's unique ability as an interlocutor, I have often told to friends and written about Mabel's telling a colleague from Stanford about "the woman who loved a snake." I had taken this colleague, a fellow graduate student, to visit Mabel, whereupon Mabel began talking about a woman she once knew who lived with her husband in the hills above Nice, in Lake County. The husband worked nights, tending cows and young calves, and one night after he left the house, as the woman was finishing the dishes, she heard a knock on the door. The woman was alarmed; she sensed something peculiar, even wrong. Against better judgment, she opened the door and found, to her surprise, a handsome man, quite tall and dressed in black. She let him in.

As Mabel put it, I guess one thing led to another. When the husband returned in the morning, he found a small black snake coiled up at the bottom of the vase on the kitchen table. He took the snake outside and let it go in the brush. The next day, the same thing happened—the husband came home in the morning and found the snake in the vase on the kitchen table. Two more times it happened this way—the husband found the snake. On the fifth morning, he said, "Something is wrong here. I'm going to kill this snake." Holding the snake in one hand, he reached with the other hand for a knife from the kitchen sink, and then he headed to the door—at which point the woman broke down in a flood of tears and confessed her infidelity with the tall handsome man dressed in black. "Well then," the husband said, "now I'm really going to kill the snake," and he went outside and cut the snake into

several pieces. But, as it turned out, the snake was there the next morning, and each morning after, again and again.

Mabel stopped talking, and my friend, writing her dissertation on some aspect of Renaissance literature, asked Mabel what the snake symbolized.

"I don't know nothing about symbols," Mabel answered.

Mabel then recalled a warm summer evening in Lake County, when, parked in a car, she saw a tall man dressed in black come out of the grocery store in Middletown. He was carrying a bag of groceries and, instead of taking the road, he went down into the dry creek bed adjacent the store and began walking northward, toward the hills.

"I think that was the man—the snake," Mabel said. Then she added with a chuckle, "And he was—he was real handsome, that guy."

My friend, her question still unanswered as far as she was concerned, became all the more frustrated. "I mean, Mabel, was it a man or was it a snake?"

Mabel appeared to think a moment. Then she looked at my friend.

"I don't know," she answered, "but it was a problem."

Stories and then more stories. Mabel's stories and our memory of and retelling of the stories—how many times have I told about "the woman who loved a snake"?—not only challenge the confines of our thinking, but help us to understand ourselves as thinking, cultured beings in a world we share with other people and all forms of life. Consequently, we can begin to think of ourselves anew in place and time. We can open ourselves and, when necessary, change, heal, or as the old saying goes, find ourselves. Certainly, my very writing of this book—my writing Mabel McKay's life story—became just that for me, a finding of myself.

It has now been eighteen years since the first publication of this book. So much has happened. "The world, it happens," as Mabel would say. I sometimes wonder what she would think of things today. The son she raised, Marshall McKay, the exemplary leader of the Rumsey Wintun Tribe, known today as the Yocha Dehe Wintun Nation, is not only an important collector of Indian art and basketry, but also serves on several boards for organizations and institutions preserving American Indian art and culture, including the Museum of the American Indian in Washington, D.C. Clearly, Mabel's influence can be seen in the person closest to her. Likewise, Violet Chappell, in carrying on the teachings and instructions of her mother, Essie Parrish, incorporates Mabel's songs in "prayer sessions" held on the Kashaya Pomo Reservation. Mabel's baskets remain on display and in permanent collections throughout the country. Her art and songs are timeless. No less, then, her life, from which these things came, and what we can glimpse of that life yet today—timeless, transformative.

It was by looking at the land about my house this morning—and seeing the smoke and soot in the sky—that I got my answer about how to start this preface. I was walking in the garden, wondering what to write, when I found myself distracted by the hazy sky and began worrying about the dry brush outside my yard—I worried about fire on this mountain. My lavender, which feeds so many bees, looked dry; the mimosa tree that draws the hummingbirds, wilted. Mabel came then, clear as a bell. I heard her talking about her Dream. And more: "You got water in your well, don't you? . . . Well then, water the lavender, water the mimosa."

Sonoma Mountain
August 2012

Northern California,
Indian Nations

Sarah Taylor's Granddaughter

I never knew nothing but the spirit.

The scene was typical. Mabel lecturing, answering questions from an auditorium of students and faculty who wanted to know about her baskets and her life as a medicine woman. As always, she was puzzling, maddening. But that morning I studied her carefully, as if I might see or understand something about her for the first time. She had asked me to write her life story, and after knowing her for over thirty years and with stacks of notes and miles of tape, I still didn't know how.

"You're an Indian doctor," a young woman with bright red hair spoke from the middle of the room. "What do you do for poison oak?"

"Calamine lotion," Mabel answered. She was matter-of-fact. The student sank into her chair.

A distinguished-looking man in gray tweed raised his hand. Mabel looked down from the podium to the front row where he was sitting.

"Mabel, how old were you when you started weaving baskets?"

Mabel adjusted her modish square glasses. "Bout six, I guess."

"When did you reach perfection?"

Mabel didn't understand the professor's question and looked to where I was sitting, behind a display table showing her baskets.

"When did your baskets start to be good?" I ventured. "When did you start selling them?"

Mabel looked back at the man. "Bout nineteen, eighteen maybe."

"Was it your grandmother who taught you this art?"

"It's no such a thing art. It's spirit. My grandma never taught me nothing about the baskets. Only the spirit trained me." She waited for another question from the man, then added, "I only follow my Dream. That's how I learn."

The young woman from the middle of the room shot up again. Clearly, she was perplexed. "I mean, Mabel, do you use herbs and plants to treat people?"

"Sometimes."

"Do you talk to them? Do they talk to you?"

"Well, if I'm going to use them I have to talk, pray."

The woman paused, then asked, "Do plants talk to each other?"

"I suppose."

"What do they say?"

Mabel laughed out loud, then caught her breath and said, "I don't know. Why would I be listening?"

At that point the professor who had sponsored Mabel's visit announced that time was up and that people could look at Mabel's baskets on their way out. He reiterated the fact that Mabel was an Indian with a different world view, reminding the audience of her story earlier about meeting the

Sarah Taylor's Granddaughter

Kashaya Pomo medicine woman Essie Parrish in Dream twenty years before she met her in person. The professor, an earnest man in his mid-forties, turned to Mabel. "You must have recognized Essie Parrish when you first saw her in person, didn't you, Mabel?"

Mabel, who was fussing to detach the microphone from her neck, looked and said, "Yes, but she cut her hair a little."

There it was. Quintessential Mabel. Nothing new. Same stories and questions. Same answers. This small Indian woman, over eighty years old, with coifed black hair and modish glasses, this little Indian woman in a mauve-colored summer dress adorned on the shoulder with a corsage of imitation African violets, had turned a Stanford auditorium upside down. No one cracked her.

On the way back to the Rumsey Reservation that day, I kept wondering how I was going to write about Mabel's life. She was baffling, even for me. Certainly the facts of her life were interesting and warranted a story. World-renowned Pomo basketmaker with permanent collections in the Smithsonian and countless other museums. The last Dreamer and sucking doctor among the Pomo peoples. The last living member of the Long Valley Cache Creek Pomo tribe. The astute interlocutor famous for her uncanny talk that left people's minds spinning. The facts were easy. The life was not.

We drove east on Highway 80 toward Sacramento. It was a hot October day; it had not rained and the hills beyond the Bay Area were dust gray. Mabel patted her brow with a clean white handkerchief. Her black patent leather purse sat open on her lap.

"Can I smoke?" she asked.

Sarah Taylor's Granddaughter

I knew she'd ask before long. She was polite. She had smoked all the way from Rumsey to Stanford, but remembered that my red Honda Civic was new. In fact, the trip to Rumsey and back was the first major excursion I had made with the vehicle.

"Car's doing pretty good," Mabel said from the side of her mouth as she lit a cigarette.

I pulled out the half-full ashtray. First thing to clean when I get back to Stanford, I thought. So much for the new-car smell.

"Drought coming," Mabel said exhaling a cloud of smoke. "Grandma said one time everything dried up. Peoples had to go clear to Sacramento for water."

"Yes, she followed Highway 16 from Rumsey to Woodland in a wagon. Was a dirt road then. No water in Woodland, so she went on to the Sacramento River. One of the horses died. Lots of animals died. She stayed along the river until the first rains came. She was hungry. She ate fish mush and drank willow bark tea." I knew the story. It seemed I knew all the stories. Over the years, ever since I was a kid, I had heard them again and again.

"Yes," Mabel added, "and lots of them valley people there suspicious of Grandma on account of her grandfather having that white snake poison. Saying problems is on account of her. Thing is that man had that poison sold it off. Some peoples even think I got that poison." She chuckled at herself and puffed her cigarette. "How can I be doctor and poison you at the same time?"

"See Mabel, that's the problem. Your stories go all over the place. I can't write them like that. It's too hard for people to follow. I don't know where to start."

Mabel exhaled another long cloud of smoke and rubbed

Sarah Taylor's Granddaughter

her cigarette out in the ashtray. She folded her hands reso-
lutely over her purse. I saw from the corner of my eye; it
seemed the gesture was intended for me. I focused on the
road.

"Mabel, people want to know about things in your life in a
way they can understand. You know, how you got to be who
you are. There has to be a theme."

"I don't know about no theme."

I squirmed in my seat. Her hands didn't move. "A theme is
a point that connects all the dots, ties up all the stories . . ."

"That's funny. Tying up all the stories. Why somebody
want to do that?"

"When you write a book there has to be a story or idea, a
theme . . ."

"Well, theme I don't know nothing about. That's some-
body else's rule. You just do the best way you know how.
What you know from me."

Back to the facts. I drove on in silence. Mirages rose from
the hot pavement. Stories. Old Grandma Sarah Taylor on her
wagon. The buckets of dirty clothes rattling on the wagon
bed as she steered the horses over the hard, rocky ground to
the creek. The sickly little girl next to her who was Dreaming
in a world of white people . . .

It was a summer Monday like so many others. Wash day and
one-hundred-degree heat. Only today Old Sarah didn't leave
her granddaughter under the willow tree. After she watered
and tied the horses, she lifted the frail seven-year-old to the
ground and sat her in the sand near the washboard and
pounding rocks. With three sticks and the sheriff's wife's cal-
ico housedress, she built a tent over the girl. Then she began

Sarah Taylor's Granddaughter

to unload the wagon. Underclothes, trousers and shirts, dresses, children's clothes. The buckets that belonged to the woman on the hill, those from the sheriff's wife and from the storekeeper. She placed them in a row along the water, but all the while she watched the clump of silver willows downstream and the chaparral behind her. She watched the horses, seeing where they turned their heads.

She had sensed something wrong just beyond the Rumsey store, when she was hardly out of town. Someone watching her. The horses lifted their heads. She pulled in the reins and started shouting. "What do you want? I've got the white people's things. I've got the ghosts' clothes. If you touch me, they'll track you." She called out in the local Wintun language, then in Sulphur Bank Pomo, and then in Wintun again. She knew half a dozen languages and she called out in every one of them. Every one of them except her own, Lolsel Cache Creek Pomo. On and on she shouted. And then as quickly as she had started, she stopped. Slowly, she let out the reins, and with her one free hand untied the scarves around her head. She needed to see from the corners of her eyes. She needed to take precautions. So before she knelt in the water with the dirty clothes and washboard, she did one more thing. She hung the sheriff's shirts on the wagon, from the bed and over the seat back.

She pulled a bucket close to her and knelt in a shallow pool. She looked over her shoulder. "Mabel," she called. The gaunt child looked up with sleep-swollen eyes. She was sitting just as Sarah had left her. "Lie down," she said. "Put your head on the scarves there." The girl stared at her, her large, wide face unmoving. Sarah turned back to her work.

The girl would sleep. She had been up half the night, talking out loud in her Dream. Sarah started on the underclothes.

The way a person dresses. First things first. She hadn't let the white people down in ten years. Mondays, wash. Tuesdays, iron. Other days, outside chores, paint, chop wood. Or the orchards. When she walked into town last spring after a five-month stay in Cortina, the white folks asked her back. They let go the Indian help they had hired to replace her. "Old Sarah, the best," they said, which is what she repeated at the end of each day's work as they dropped a coin into her apron and handed her a loaf of bread, sometimes a box of crackers, for the sick girl at her side. Old Sarah, the best. It was about the only English she knew. She wasn't that old really, fifty or so. Her weathered face and old Victorian dress and loose aprons told nothing of the arms and back that hoisted sixty-pound boxes of apples and pounded clothes eight hours straight.

The sun on her bare head would make her delirious in time. She knew working faster wouldn't help. Neither would crying. For that she only allowed herself the time each morning it took the sun to hit the mountaintops. She had to go on. There was the girl. Mabel. Go on, she told herself as she glanced at the girl and took up a handful of underclothes.

It started about four years ago, shortly after the child began speaking. The long, full stares. Restless nights. The strange things she said. "It's good to be here, away from that Big Lady by the lake," she told her mother once. She was referring to her father's first wife, who had tried to poison her mother up in Nice. But how could she have known anything about that? She was an infant then. How did she know to call the woman Big Lady? Then once when a man from somewhere near Sacramento knocked on Sarah's door, the girl grabbed a piece of meat off the table and handed it to Sarah. Sarah, who stood in the doorway facing the man, took

the meat from the child without thinking. When she looked back at the man, he was stepping backward, away from the door, the reflection of her and the girl vanishing in his frightened eyes. Mabel pushed him backward, down the road, with her gaze. He had come to poison Sarah, and Mabel had known as much, even at the age of three. She knew to show him meat. Offer a stranger meat. If he doesn't take it, he is carrying poison. A poisoner must fast from meat. The old Indian rule.

Maybe that's who is after us, Sarah thought as she pushed an undershirt over the washboard. He saw the girl was different, that she had something powerful and old. Others had seen, too. Those people last fall at Mrs. Spencer's grape-picking camp who had heard the girl cry and hum at night and seen her heavy eyes in the day. It could be any of them. This wasn't the first time Sarah felt someone following her.

Maybe it was some good person, a good doctor watching, keeping an eye on the girl until she was ready to be helped with the Dream. Sarah didn't linger on that idea, though. In people's minds, the girl called up Lolsel, or Wild Tobacco, the ancient village place where Sarah was born, and where now only her sister Belle remained. Lolsel, in the hills above Clear Lake, some twenty-five miles west of the valley, of Rumsey. Lolsel, where Sarah's brother, Richard, began the Dream religion, where he called people from far and near to hear his Dreams, where people listened and began Dreaming themselves, Dreaming new dances and songs, sacred activities that would keep them alive after the white people had taken everything but their souls to Dream. Bole Maru, they called the Dream religion in the west. Bole Hesi, in the east. But Lolsel was always special. Always a place of powerful people, astonishing events. The small valley tucked in the

hills, where strong medicine grew. Where white eagles appeared to the people and traded doctoring songs for live rabbits and small deer, and later, out of gratitude for the good trade, gave one old man there enough white feathers for a full-length cape, a gown so brilliant it exposed every sickness in its path, every darkness in a human body.

That was Old Taylor's father, or maybe his father's father. Sarah's grandfather, or great-grandfather. The same one who discovered the snake one dry summer in Cache Creek just north of the village. A snake a hundred feet long, twenty feet wide, pure white with the head of a deer. It filled the creek bed; it was stuck, unable to slide past the stone-dry creek walls. He sacrificed the snake, killed it with song. He called many people to see it, then ground its dried remains into a powder that he sold to all the neighboring tribes. It was a deadly poison, but he figured if everybody owned it, nobody could use it. You counteracted the poison with the poison. But things got mixed up. The white people came not long after. An awful time. The stories got mixed up. People were always suspicious of strangers, persons from other villages, and now they were forced to live with them, work with them. Sometimes entire villages disappeared. Maybe a few from here survived, a few from there. Smallpox left Lolsel with hardly a dozen people. Once a large village of five hundred, only a handful by 1871 when Richard preached his Dream. But someone remembered about the snake, and told it wrong. When Sarah moved into the small house in Rumsey, someone said, "She has that white snake poison. That old ancestor of hers didn't sell it all. Why else does she look so good to the white people? She makes us look bad. It's her poison."

Sarah got a ride into the valley with the rancher. She

Sarah Taylor's Granddaughter

stood outside the barn where he hitched the horses and she pointed to the road. He knew she was leaving the place. It wasn't just the gunnysack of clothes at her feet, which she took with her whenever he gave her a ride anywhere. And it wasn't just that she was pointing east toward the Sacramento Valley on the coldest day in winter, when snow was on the hilltops and there wasn't an almond to crack or an apricot to pick anywhere in Rumsey. It was that a week before, her oldest children had come for her youngest. The older boys, young men really, Nelson, Anderson, and Dewey, who built the rancher's stone fences and cleared the land for his cattle, came on a wagon of their own, a wagon with fine wheels and a long bed, and loaded up the younger brother, McKinley, and the girl, Daisy. How could he protest? There wasn't really enough work for them, and now he couldn't afford to feed them well. Game was scarce and his own family needed what supplies he could get in Rumsey. And now didn't it make sense that the old woman would follow her children?

Sarah let the man with long red sideburns help her onto the wagon. His worn leather gloves felt cold, smooth. They started off then, past the barn and the rancher's house, past where Sarah could see the Indian shacks by the creek. The half dozen or so places looked small, abandoned, except for where smoke rose from a single stovepipe. The wagon bumped and made the corner away from the ranch. Sarah turned in her seat, kept looking back after the barn and Indian places disappeared. She could still see the elderberry tree in the open, flat field. It was bare now, of course, but its drooping branches held full white flowers each spring and dark blue berries every summer.

It was the last miraculous thing to happen at Lolsel.

Richard Taylor, Sarah's brother, died one late fall after-

noon. The night before, he instructed his people to bury him in the Roundhouse, where he preached his Dream. After, they were to lock the Roundhouse, since no other Dreamer would live at Lolsel. He was the last. That was hard enough. But then the rancher, who bought the land from a white man, announced that he was going to move his family there. He wanted the land cleared, and he looked at the wide round rooftop rising out of the ground in the middle of the field. He said he would come back in the spring. That winter the creek flooded, the worst rains ever. People moved into the hills. When they returned, they found their places, all their possessions, in order. Everything except the largest structure on the land, the Roundhouse. It was gone, centerpole and all. Only the indentation in the earth where it once stood told anything of its ever having existed. And after the rains and flood, the large crater in the earth was dry. That next spring, where the entrance had been above ground, a lone elderberry grew. People said Richard Taylor ascended to the world above.

The rancher couldn't have known what Sarah was seeing any more than he could've known all that was in her mind when he found her outside the barn. He knew Belle, Sarah's sister, was left, that Belle would stay on to help his wife. He'd seen to that after the older boys moved to the valley. Belle and, now with Sarah and her younger kids gone, nobody on a regular basis. Maybe that old man from the lake someplace who had been around the last five years, that old man whom he couldn't see Sarah thinking about that morning, talking to Sarah. "You got children to look after," he told Sarah. "This is white man world. And the Indians down there aren't always friendly. You go . . . stay together. There's nothing for you here." He was sitting up, his rattling chest heaving with each breath. "Go on," he said, and looked to Belle. "She'll

come later. Then no Indians left of this place. But I'll be here." Sarah knew what he was saying. It was enough for him to die there. He didn't need or want more from her. Except to leave him, to join her children. "You got a place down there," he said. "Now go." She figured, at her age, he would be her last husband. She just never figured it would end like this, at a time when the life ahead of her seemed so long.

She thought of things on the way to the valley. She thought of her mother, Mollie, who had come to Lolsel from a village far south, in the Napa Valley. She was a stranger; no one understood her language. She was alone, frightened, and her hair was singed close to the scalp, a sign she was in mourning. But she worked hard, and she made beautiful baskets. Once she wove a basket the size of a grown woman, another time she made a string of baskets tiny as beads, so tiny that people could hardly see them to know what they were. She gave each Lolsel person one of the little baskets. She was close to middle age, and still Old Taylor took her for his wife. After she learned to speak the Wild Tobacco language, she told how she fled north after the Mexicans kidnapped her children and burned her village on the Napa River. Sarah thought how she had never seen Mollie cry.

The ride down was slow. The ground was hard, slippery. In the valley, where the road was flat, the horses had an easier time. Rumsey wasn't too far then, and Sarah tapped the rancher when she saw the house and barn on the other side of the general store. She got herself off the wagon, took up her gunnysack, and nodded to the rancher. Then she started up the narrow road past the large white ranch house with a picket fence to the smaller house behind the barn. Anderson was chopping wood, and he saw her right away. He called

his sister and brothers out of the house to greet their mother.

Her children had done well for themselves. The place was small, two rooms, but it was clean and dry. It had a good stove, and there was enough food—flour, and even some canned goods from the store. The boys chopped wood for the local ranchers, sewed feed sacks at the granary, loaded and unloaded boxcars at the train stop. The girl cooked, washed clothes. But Sarah was still suspicious. Why did their distant cousin, who had Lolsel lineage, leave such a nice place? It was winter now, and even though they were only a few miles from the Wintun rancheria across the creek, they did not see other Indians too often. In the summer, the Indians would be everywhere.

Sarah thought through the situation. She knew most of the Wintun people, she had worked with them in the orchards for many years, and, as far as she knew, she had good relations with them. She would strengthen the ties, make sure none of them turned on her or her family now that she was settled in their territory. Marriage was the key. That summer in the orchards she nodded to every available Wintun woman she found. The boys knew to follow her chin. She instructed Daisy to comb her hair and keep her clothes clean at all times. She taught her how to make a good black pinole that she could share with people, not just men lest the women suspect her motives and become jealous. By fall, Nelson and Dewey had taken up with women, but it was not exactly as Sarah had wanted, no exchange of gifts, no formal marriages. Later, Anderson moved to Cortina with a woman. When the heavy rains came, Sarah found herself in the house with only McKinley and the girl.

By then the storekeeper's talk of her excellent work around his large white house had led to jobs with the woman

Sarah Taylor's Granddaughter

on the hill and the sheriff's wife. Daisy helped and so did McKinley, when there wasn't work at the granary or at the train stop. Then McKinley began to wander. He socialized with the local Indians and danced with them at the big dances in Cortina, which, for Sarah, was as good as if he married one of them. In time, she got used to the quiet house. She enjoyed time with her daughter, who, after so many years, still didn't have a marriage proposal.

Four years went by. Sarah knew some of the Indians were unfriendly to her, and she heard from those who were her friends what was said about her and the white snake poison. She figured she could live with the talk. No one had tried to harm her. Besides, in this world of more and more white people, weren't more and more Indians forgetting those old-time things? She worked hard, was polite, watched her step. She worried about Daisy, who was now eighteen and still unmarried. Daisy was a flirt, too casual with the men, Sarah thought. Too many different men came to visit her—so many that Sarah could hardly keep track, so many that when a couple parked their wagon in front of her house and pointed to the loaded wagon bed, she did not have any idea who their son was. There were chickens, pigs, even a young heifer. Barrels of flour and corn, a case of crackers, yards of fine material for dressmaking, piles of new blankets. The only problem was they weren't Wintun. They were Pomo, Potter Valley Pomo from west of Clear Lake.

Sarah went inside the house. Daisy was nowhere around. Sarah waited all day. So did the couple on the wagon. When Daisy came home that evening, Sarah pleaded with her to wait for an offer from someone in the valley. But she didn't push too hard, since she didn't want to offend the dark handsome man who stood next to Daisy and called himself Yanta

Sarah Taylor's Granddaughter

Boone. He might be able to understand some of her Lolsel language, after all. When he did address Sarah, he spoke Sulphur Bank Pomo, a language they both understood. "My parents are paying the highest price for your daughter," he said. "A woman from Lolsel is the most valuable anywhere." "We're nothing special," Sarah said, wanting to believe her own words. "Take the gifts," Daisy said in Sulphur Bank, putting Sarah on the spot. So Sarah agreed, and Yanta and his father unloaded the wagon, and Daisy left with a gunnysack.

That was in the spring. April sometime. Sarah wasn't alone. Dewey was back without his woman, and McKinley was there. The other boys visited regularly. Sarah told them what happened to Daisy. She told how Yanta Boone had a regular job on a ranch in Nice, just north of the lake. "That's closer to our home," Sarah said, as if to make things all right. "She'll be happy there." The boys weren't convinced. How did Sarah or anyone know anything about this Yanta or his family? they wondered. Sarah pointed out that Yanta's sister, Nanny, had married Charlie Williams, the lone survivor of the Bloody Island Massacre, who was a fine man. Still, the boys were not appeased. Someone would have to check on Daisy.

Sarah would be the one.

Just after the last crops and before the first heavy rains, Sarah made the trip. The boys lent her their wagon. They hoisted enough straw on the bed to feed the horses for a week, then followed her on horseback to the foot of the hills. Now she was alone. It was early morning, and if she didn't stop, she could be in Nice by nightfall. But at noon, when she was well into the hills, halfway to Clear Lake, she turned off the road. She didn't hesitate. There were no second thoughts.

Sarah Taylor's Granddaughter

She drove on, around that turn in the narrow road where she spotted the elderberry tree in the open field, onward past the house and barn, along the shacks, until at last there was a woman on the ground holding the horses and calling her name.

The two sisters had a lot to talk about. There was talk about life in the valley, the boys and Daisy. There was talk about the ranch and how cattle were everywhere now. By the time Sarah thought to get up from her place by Belle's wood stove and have a look around outside, it was already dark. By then Sarah had seen that the pallet bed in the corner was gone, as was the wooden apple crate next to it that held her husband's few belongings. The place was neat and tidy, dry-smelling like an orderly and lonely old woman.

Belle served acorn mush with a dinner of fried beef and cabbage sent over from the rancher's wife. Sarah and Belle talked into the night. Mostly about the valley and how, with so many white people, the world was changing even faster than before. "Richard's Dream was true," Sarah said. "There will be roads going everywhere, even to the moon." They sat on the floor, in the old style, their long dresses spread out around them, even though Belle had a new table with four perfectly comfortable wooden chairs. And when they got sleepy, they camped right there, folding up their shawls for a pillow.

Sarah had not taken a good look at things on her way in. She had not seen how the grass was grazed to the bare earth, not just in the open field, in the little valley that was Lolsel, but over the hills in every direction as far as the eye could see. "Cattle," Belle explained, when Sarah took in the damage the next morning. They walked about, past the large oak tree along the creek. It looked dry, hungry. And along the water,

Sarah Taylor's Granddaughter

where sweet clover grew year round, there was nothing but rocks, dusty earth, and cow dung.

On the way back, Sarah turned off the trail, just beyond the oak tree. Belle followed. They stopped at the graves above the creek. Sarah glanced around, then caught Belle nodding toward the grave she was looking for. Belle left and waited by the barn. Sarah looked awake but very distant. Something about her eyes. How they were last night, how they were all morning, how they looked when she reached the grave. Full of the unspeakable. That which breaks the insides to pieces. Which she and Belle cautiously avoided talking about. Not just what-happened-to-my-husband. Sarah knew that. But the countless remember-whens that made up her life at Lolsel.

Later that day, back on her way to Nice, Sarah began to think of things. Memories floated up. But she pushed them back where they came from, in that space that made up everything she knew except for what was immediately in front of her. "Go on," she said and shook the reins.

The ranch was easy to find. She found the endless stone fences her son-in-law had made and the barn and the cottages behind. Daisy came out to greet her, and she saw immediately that Daisy was in a family way. Not just that Daisy, who was rather stout anyway, was bigger, but that her face had changed, settled in a way Sarah had seen in many pregnant women. And it was in Daisy's face that Sarah detected in the days ahead that something was wrong. Nothing about the place; it was clean and warm. Nothing about Yanta; he was polite, good to Daisy, even if, as Sarah discovered, he was absentminded, wishy-washy at times. It was what Yanta's parents hadn't said that day on the wagon outside Sarah's house, what Daisy finally told Sarah at the end of

Sarah Taylor's Granddaughter

their visit, after days picking herbs in the hills, cracking acorns for mush in the evenings. It was that Yanta was already married. He had a first wife. She was from the lake someplace. Yanta's parents didn't like her; apparently he had married her without their approval. They paid such an extraordinary price for Daisy because they figured a woman from Lolsel would keep this lake woman away.

It didn't work out exactly that way. Yanta was not interested in her. But she did not want to let him go. With friends, she made trips up to the ranch. She would stand out on the road for the longest time. Daisy was afraid to leave the ranch by herself, thinking she might run into this woman who gave long, hard stares. It wasn't good. Daisy felt like a prisoner, stuck on the place. And just the week before, one of the Mexicans found a sun basket, perfectly made with the red feathers from a woodpecker's head, hanging behind the cottage. Yes, someone was trying to poison her. Who else but this woman?

Sarah was packing her gunnysack and thinking to herself that she did not want to hear what she was being told. She asked who the woman was. "They just call her Big Lady. I guess that is her name," Daisy answered. "She is a big woman." Sarah then inquired about the woman's family, where they were from. Daisy didn't know too much, other than that they came from the lake someplace. "Well," Sarah said, picking up her gunnysack, "remember all I taught you about yourself and having children . . . And if . . . you can always come back to the valley."

Which is what Daisy did one gray February day. With Yanta. And with an infant girl she called Mabel.

At first, things seemed all right. The little house behind the storekeeper's barn was crowded, but it was good to have Daisy home where she was safe. Big Lady had finally got her

Sarah Taylor's Granddaughter

hooks in Daisy. Not long after the baby was born, Daisy became deathly sick. An old man from somewhere nearby doctored her. He said Big Lady and her family had hired a poisoner, and while the old man said he could heal Daisy, he warned her that the poisoner would strike again. Sarah informed Daisy that the old man doctor was a distant cousin, a descendant of a Lolsel woman. "I always called him Uncle," Sarah said, "even though he grew up along the lake, lower lake, I think, among his father's people." She hoped Yanta paid him well. Sarah never found out what Yanta paid, since Yanta didn't say. Yanta didn't say much of anything, which was just one of his problems as far as Sarah's family was concerned.

The boys found him unmotivated. He would sit by the stove or, if the weather was good, on the back porch, gazing at the western hills all day if someone didn't tap his shoulder to let him know that a train had come in or that a rancher's fence needed mending. And he didn't raise an eyebrow, he wasn't the least concerned, when Daisy took off by herself for a dance in Colusa. What kind of man is that? the boys asked. What kind of husband? Yanta seemed more interested in the small spotted dog that was always at his side than he was in his own child. The boys gave him the worst jobs, cleaning the outhouse and the storekeeper's chimney, just to see if they could get a rise out of him, some protest. But nothing. He did the terrible jobs. Until one day he disappeared. He took nothing, none of his clothes, only his hunting rifle and the spotted dog. Four months later, Daisy moved to Colusa to live with a Wintun named Andy Mitchell. She left the baby with Sarah.

The first thing Sarah noticed, even before Daisy left, was that the child was unusually quiet. The little girl was obser-

vant enough, her eyes darted about all the time, but otherwise she was still, solemn. The boys thought she would be lazy like her father. Sarah didn't know what to think. In time, Sarah had her hands full keeping the girl out of mischief, as she would any child. Once little Mabel swallowed kerosene. The white doctor came all the way from Woodland and pumped her stomach. For the longest time, she could only take puréed fruits and vegetables. "Maybe that's why she's turning out so strange," one of the boys suggested. But by then Sarah knew it was something else. She had heard the girl mumble in her sleep, she had seen the long stares, and watched her chase away a poisoner with a piece of meat. She had noticed the girl was thin, far too thin, even before the kerosene accident. No, it was something else, and it wouldn't stop.

Sarah tried to downplay the situation. "She's cranky and damaged because of the accident," she started saying. She told her family that, just as she told it to the Indians in front of the store or in the orchards when they stopped and stared. She told it to the white people who said the little Indian girl looked like she was starving to death. Mabel didn't grow. She shrunk in, close to the bone, so that her cheekbones and the indentations on the side of her face showed, the way they do on very old or very sick people. Because her body was so thin and undeveloped, her head, even as bony as it was, looked disproportionately large. Something's *wrong* with Sarah Taylor's granddaughter, people began to say.

Wrong. Sarah knew the kinds of things people meant. The boys told her what people were saying. Stories about Lolsel came up. Stories about the white snake poison. Some said Sarah was being punished because she used her poison to charm the white people. Others claimed it was a curse from

way back, from the time Sarah's grandfather sacrificed the snake. Still others thought the girl had a strange disease that might be catching. They did not want their children to go near her. There was an old lady from Cortina, where Anderson was living, who felt the girl was special in a good way. Whatever people said, though, Sarah showed little reaction.

But it was hard. The girl caused quite a stir. Still, Sarah found that going about her public life—washing clothes, harvesting apricots, then peaches, then apples, then pears, then prunes, then almonds—amid people's curious stares and fast stories was not as difficult finally as the frustration and helplessness she felt at home alone when the girl wouldn't eat or screamed at the top of her lungs in the middle of the night. She knew what was happening, the girl was Dreaming, and she didn't know where to turn for help.

At night, Sarah prayed, sang what songs she thought might help Mabel. Each day seemed to bring another challenge. Now federal government officials were rounding up all the Indian children and hauling them away to boarding schools. They checked regularly to see if Mabel was well. Sarah took off Mabel's dress each time and scared them away. More than once she felt people following her as she went about her work. Still, the nights alone were the worst, and sometimes, exhausted, she found herself saying over and over again, as if the words would make a difference, "If my father was alive, you wouldn't be this way . . . If my father was alive, you wouldn't be this way . . ."

Mabel heard Sarah say this, but she didn't know what Sarah meant. She didn't know Sarah was thinking of Old Taylor's powerful medicine, the ways he might help and guide Mabel. Mabel didn't know too much. She didn't ask. "You listen to me," the voice was saying. "I'll teach you. You

Sarah Taylor's Granddaughter

don't tell nobody what I'm telling you. You don't ask them questions about it. You're being fixed to be doctor." "What's doctor?" Mabel asked. "You'll know when the time comes." But what the spirit was showing her did not seem good. She saw blood, poison. Ugliness. People carrying bones from the dead, grinding the remains of the orange-bellied newt, weaving the woodpecker's red feathers into sun baskets. Bodies swollen and distorted, discolored. Bodies with black growths like roots. Crying. Misery. Hatefulness. She couldn't trust anything around her. Once while she was sitting by the willows waiting for Sarah to finish her wash, a small colorful bird appeared before her. "Close your eyes and follow me," it said. And Mabel did as she was told, only to find herself in a dark cave where poison was being ground by an old woman on a red rock. She screamed, as she always did, and waited for Sarah's arms.

Sarah began to feel desperate. She thought of things. Like the fact Mabel was never blessed, dedicated in the traditional way. She was not given a name in the Roundhouse. But what Roundhouse? The one at Lolsel was closed a long time ago. What Dreamer? What spiritual person? What Lolsel? What people? A lonely old woman in a one-room shack who takes care of white people's children? The other one who washes clothes in the valley and carries around a sickly grandchild? Lolsel was a dream now, a memory that seemed useless. Richard Taylor had said there would be a new world. So this was it. A world of white people and strangers. New world that was no world. Why, then, this child in a place that was not home? A mean trick played on a woman burdened by enough mean tricks already.

McKinley, who was the only son around on a regular basis, suggested that Sarah move to Cortina. He thought she

would feel better up there. He said the Indians were friendly, that they took in strangers, and that they still performed the Hesi and Big Head dances. McKinley danced with the Rumsey Wintun there. He thought the ceremonies would do her good. Maybe someone there might even be able to help Mabel.

In the fall, after the last crops were in, Sarah gave notice and left Rumsey. She wasn't going to a place where she didn't know anyone. Her son, Anderson, lived in Cortina, after all, and when Sarah showed up at his door on the small reservation, Anderson's wife took Sarah and the girl right in. The woman's name was Rosie. She was a stout, attractive woman who kept a neat house and food on the stove. She was happy her three children had a grandmother and a cousin.

By now Sarah knew enough Wintun so she could converse easily. While Anderson worked, finishing the pruning in the fruit orchards, Sarah and Rosie cooked and visited. Rosie knew everybody, and everything about them. Sarah saw that she was respected and well liked among her people. At times, Sarah felt that she wasn't contributing enough. The crop harvesting had ended, and there wasn't a white person around who needed clothes washed. She knew no white people in Cortina. She had to depend on what Anderson brought in. But she didn't have a lot of time to worry about herself and what she could or couldn't do just then.

Excitement was everywhere. The old-time dances were on, and people from all over came to dance. People from Sulphur Bank in Lake County. Grindstone people. Colusa. Rumsey Wintun. Pomo. People Sarah hadn't seen in years. People she had never seen. They came on horseback, piled on wagons, alone on foot, and camped in view of the Round-

house, whose roof rose up to a peak in the middle of the open field. The women cooked up black and green pinole and acorn mush. They prepared baskets of fresh clover and pepperwood balls. Old-timers from the valley toasted grasshoppers. Meat was baked in large underground ovens. Everybody had some specialty to offer.

The men who danced wore elaborate and colorful Big Heads, great feathers on top, and streamers of yellowhammer feathers down their backs. The women sometimes wore headdresses, but not nearly as large and lively as the men's. Some wore shell pendants, abalone and clam, over their faces and on their dresses. In their hands they held long scarves, which they moved and waved as they danced in a wide circle around the men in the center. Frank Wright and Charlie Wright were *Sectu*, Roundhouse bosses. Frank stood on top of the Roundhouse, just in front of the smoke hole, and called in the different groups. Sarah went in with the Rumsey Wintun, because her son danced with them, and because she had been living in their territory and wanted to show them her respect. Only she did something she wasn't supposed to do: she brought a small child into the dance house.

Mabel cried. She did not want to be left alone. She hid under Sarah's dress. Tiny feet that danced when Sarah danced, sat when she sat. People saw and laughed. How cute, Sarah Taylor's granddaughter, the little sick one. Only the *Moki* did not think it was funny. That was the clown, *Moki*. A man covered head to toe in a striped black-and-white eagle feather cape. Nothing showing but his eyes and nose, so that no one knew who he was. The crucial element of the Hesi dance. He said nothing and was still only when Frank Wright came into the Roundhouse after everyone was gathered and named each plant and animal that had been har-

vested for the people. Each thing that was to be danced for. Once in the fall and again in the spring. If anything was forgotten, it would not grow anymore. The people would have to do without. And the *Moki* checked to see that all the rules were followed. He passed each person. Some he shook a stick at, or a cocoon rattle—that meant they were supposed to sing or leave a larger offering by the centerpole. He squealed, made high-pitched noises that were unearthly. Sometimes, he imitated people, their voices and gestures. The first three nights he took no notice of Mabel. On the fourth night, the last night, he went mad.

He started scooping up hot coals in his hands and throwing them around the Roundhouse. The rafters caught fire and people's clothing. The place filled with smoke so no one could see a thing. People panicked and made for the front and back doors. Sarah was closest to the back door, so she started out there. "Grandma, Grandma," Mabel screamed, clinging to Sarah's long dress. "Grandma, Grandma," Mabel heard someone saying in her own voice, and when she turned, she saw that it was the *Moki* coming up behind her with a burning ember in his hand. He forced the hot coal into her shoulder, as if it were a cattle brand, and she screamed with all her might.

It was odd. The next day there wasn't a mark on the girl. Nothing. But Sarah stayed hidden in Rosie's house. She heard the talk about how the *Moki* was enraged. It had been announced that the *Moki* would not appear again. People were saying that they had to put away their eagle feathers. The dances would be different from now on. Their feathers would be from turkeys, tame birds. A lot of the old foods would be gone. Sarah felt it was her fault.

An old Cortina woman convinced Sarah otherwise. She

was Mary Wright, the mother of Frank and Charlie Wright. One night, not too long after the fall Hesi, she visited Sarah. She had two men with her, who were even older than she was. She told Sarah that the trouble was not her fault, that the dances and the people were changing. She talked about the white man's rule forbidding them to kill eagles. So much has changed, she said. Then the old men spoke. They were Stiffarm Jim Coper and his cousin Johnny Cline. They had grown up far in the south, below Mount Diablo, where their ancestors had prayed since the beginning of time. They escaped the Spanish who leveled their village, and fled north to Cortina. They talked about how no one was left to pray and give thanks for that sacred mountain. Sarah nodded. She understood. "Mary took us in, adopted us here," they said, "and that's why she is here tonight. She's going to adopt in your granddaughter. Give her a name and a place."

So it happened. Just a few people in the Cortina Roundhouse. Old people from here and there. They witnessed the old woman pray for the sickly girl who stood staring beside her grandmother. They heard the name *Catanum* given to the centerpole, the name that was not new, but that her mother had given her shortly after she was born, a name that had a place now. Good old Grandma Mary Wright, who offered her own beautiful baskets to the centerpole and prepared a dinner of the finest old foods Sarah would ever see again. "For my new girl," Grandma Mary said. Grandma Mary, who said in the Rumsey orchards that the girl was special. Mary Wright, whose voice Sarah listened for even after she left Cortina so she wouldn't have to take from her son and his family, after she found herself back in Rumsey, at the same place along the creek, with the girl who was just the same as before . . .

Sarah Taylor's Granddaughter

Sarah tried to think of good things, even as her eyes caught the sheriff's clothes draped over her wagon. Again, she thought of someone who had been watching Mabel, not to harm her but to help her. Someone like Mary Wright. But why didn't they show themselves? What did they have to hide? Where were McKinley and the others when she needed them, when she needed eyes in the back of her head?

Somehow she made it through the afternoon. Hadn't she always? Good thoughts, memories, fear for the girl went around and around in her head until it was late afternoon. The birds were singing and darting in the long shadows across the water when she had packed the washed and pounded clothes on the wagon. She arranged the buckets of clothes on the wagon bed so anyone looking could see she had the sheriff's clothes. Then, with the girl seated next to her, she turned the horses and started off. She rode along, past the place where the horses had lifted their heads. Now they did nothing but push along, snorting out the dust from the dry empty road.

As Sarah came into Rumsey, up to the general store, she laughed, thinking of the wagon draped with the sheriff's belongings. What if she had left it that way? Wouldn't the white people think she was crazy? Old Sarah. Crazy Sarah. But it was the wagon draped with the sheriff's clothes that Sarah herself would first think of on the day six years later when she was returning from Mrs. Spencer's place without the girl. Saved by white people again, Sarah thought, this time without a hint of anything but sorrow.

It had all started late one night when Daisy appeared from Colusa. She was alone. She had lost her daughter from Andy Mitchell. A girl named Lena. And now she had left Andy. But there wasn't any sadness about her that night. She had come

to get Mabel. Not because she wanted the girl, but because she had taken a large sum of money from a sixty-year-old Colusa man for her. "But she is only twelve years old," Sarah protested. "That's old enough," Daisy said adamantly. "But she knows nothing about marriage," Sarah argued, "and she is weak, sickly. What good would she be to anyone? She can't cook, clean house. She knows nothing. She's useless."

On and on they argued. Mabel watched from behind the bedroom door. What is this thing marriage? she wondered. Why does my mother want to take me now, after all this time? My mother, who is a stranger. Then Mabel heard the voice that was always with her. "Don't worry," it said. "Wait to see how it turns out. You'll not go anywhere in marriage. But you'll go where it's safe for you. A strange place, but you're going to be all right. Now you'll start to see everything I say is true. Watch how it turns out."

Daisy yelled at Sarah. "She's my daughter, I'll take her," she said. "No," Sarah said. "The white lady, Mrs. Spencer. You have to ask her." The thought came to Sarah like a bolt of lightning. Mrs. Spencer, who hired the Indians to cut grapes each fall. Mrs. Spencer, who opened her abundant vegetable garden to the Indians. Mrs. Spencer, friend of the Indians. No one would do anything to upset her. No one would take away a starving Indian girl she was keeping and feeding. No one. Not even fast-talking Daisy. Mrs. Spencer had wanted to keep Mabel. Now she would have her chance. "You have to ask her," Sarah repeated. "I have to take her back in the morning."

So while Daisy slept in the dark hours of the morning, Sarah was on her way with Mabel to the white two-story house with gables. And by the time the sun was on the hill-top, she was on her way back, the seat next to her empty for

Sarah Taylor's Granddaughter

the first time in twelve years. Saved by the white people, but
who would've thought like this?

Daisy left. She went back to Colusa, but only for a while. She came home to Rumsey and married Harry Mateo Lorenzo, a man ten years younger than she was, whose father, Mateo Lorenzo, was chief of the Rumsey Wintun. Mabel stayed with the old woman who wore fancy clothes and kept horehound candy in big glass jars. Sometimes Sarah visited Mabel. Sometimes Sarah took her to dig sedge for baskets or to pick herbs. But not very often. Sarah thought to leave well enough alone. She kept busy. She had her work. But the nights alone in the little white house behind the storekeeper's barn were hard. Sarah missed the girl's murmurs in the dark, the bits and pieces of her songs that made the house their place.

We drove on Highway 80 until 505, where we went north toward Woodland. If Highway 80 is long, Interstate 505 to Woodland is forever. Flat, open landscape. Cow fields. Some orchards. An occasional barn and farmhouse. Rice fields that the farmers burn each fall, filling the open sky with hot, dirty clouds of smoke. On and on. In Woodland, we stopped at Happy Steak for an early dinner. It was about four-thirty.

I noticed at the service counter that Mabel was having a hard time holding her plate. Her wrists were swollen from a recent bout with arthritis. She mentioned her problem when we sat down.

"It's catching up with me," she said. "All my doctoring things. Some of the things that went wrong. These wrists. My knee, too."

I had heard the stories. About the girl who started men-

struating while Mabel was doctoring her. About the young man who had some illness with his knee that Mabel inherited and could not expel. I did not want to see her wrists. I avoided looking at them in the car. I didn't want to know she was having a hard time weaving her baskets. I didn't want to hear that the spirit said she would be retiring from her doctoring. This news created panic in me. Then frustration. I didn't know what to do for her. Just a couple of months before, I had driven all over the valley in the over one-hundred-degree heat to find a doctor who might help her. Finally, we found a doctor who ordered large white pills for the pain in her swollen joints. I was relieved. Then, on the way home, Mabel informed me with her inimitable light chuckle that the white man's medicine couldn't help her. "It's that moonsick girl who done me in like this," she said, suddenly serious. Why in the world had I been driving all over the valley then, when she knew all along that my efforts wouldn't do her any good? What was the point?

So, again, why the mention of her ailments? Was it to get me going on her book? What was this whole adventure to record and write her stories about? What was Mabel up to now? A joke? A trick to get a university person face-to-face with the impossible and ridiculous? Another white-pill story? Why pick on me? Someone who had known and cared about her all his life. Someone who is Indian.

"Mabel," I said, "maybe we should start with your Dream."

"Well," she said, setting down a fried chicken leg and wiping her fingers on a napkin, "that's what I mean. Dream says I'm getting to that point. No more doctoring. I can't do much good anymore."

"No, Mabel, I mean for your book. When did the Dream start?"

Sarah Taylor's Granddaughter

She laughed and wiped her mouth with the napkin. "It didn't have no start. It goes on."

"But I mean the Dream. Not the spirit."

"Same thing. Well, it said to me when I was little, 'I put these things to you, and you have to sort them out.' It wasn't always a good thing. It's many. Then it's saying, 'You have to learn many bad things so you know what to do when the time comes . . .' That's why people say I'm poison. I don't know. How can I be poison?"

"Maybe we should start with the baskets. That's what people know you best for."

"Well, same thing. Spirit show me everything. Each basket has Dream . . . I have rules for that . . ."

I got up and filled my plate again at the all-you-can-eat counter. Later, when she was sipping hot coffee, she said, "You're kinda funny person. You try to do things white way. On account you're mixed up. You don't know who you are yet. But you're part of my Dream. One day you'll find out."

"What's wrong with me?"

She laughed and pulled out a cigarette from her purse. "That's cute. 'What's wrong with me?' Nothing. How can anything be wrong with you? You're young and healthy."

So what was the point? I paid the bill and we left.

We drove west and then north on 16. She pointed out the prickly pear trees along the road that she remembered as a girl when she rode into Woodland with Sarah on the wagon. She mentioned a spot along the road where someone had been murdered, where the horses always shied. The same stories. Where clover once grew. Where Sarah picked almonds. A goat farm. Sheep. Buzzards feeding on a cow carcass. Oak trees. Ripe tomatoes. Long shadows crossed the road now, things felt cooler.

Sarah Taylor's Granddaughter

To my surprise, Mabel didn't want to go straight home. When we came to the turnoff just beyond the Rumsey Wintun Bingo Hall, she motioned with her hand for me to drive on. I thought maybe with all my questions about how things started, Mabel got the idea to go to Lolsel again. Once before, after I had asked her about Lolsel, she directed me without any warning to the little valley in the hills above Clear Lake. She didn't say where we were headed. In the middle of nowhere, we came to a stop sign and a 7-Eleven and a laundromat. Beyond the sign and rows of new prefab houses, we took a dirt road that opened on an empty field. Then I knew. I saw the ancient oak tree above the creek, and I saw the large craterlike indentation in the field. Nothing else was there. No barn or house. No shacks. It was drizzling, I remember, and Mabel stayed in the car and watched as I crawled through the barbed-wire fence, past the No Trespassing sign. I found junk—old mattress springs, clothes, a rusted refrigerator—people had dumped in the crater. There was no elderberry tree. Along the creek, I found one marked grave, a concrete block with the name Belle embossed on it.

But Mabel had no plans for going to Lolsel again. Not too far beyond the reservation, a good ways before the hills, she directed me off the highway. In a minute, we were on a dirt road, or rather a horse trail. Then, in my new car, we plunged down the rocky creek bank, crossed the water, and bounced up the other side. Dust swirled up, rocks thudded underneath. On a dry plateau beyond the creek, she said, "Stop, right here."

She was gazing straight ahead to a wide smooth roll of packed dry earth. Something like the end of a rusted irrigation pipe stuck out of the ground. Piles of dried cow manure here and there marked the otherwise barren earth. "What?" I asked. "What is it?"

Sarah Taylor's Granddaughter

"There," she said, nodding with her chin. "It's where Grandma Sarah is buried. McKinley, too. Dewey, I think, too. The old graveyard."

"But this is Wintun country," I said.

"Yeah," Mabel answered. "The old Wintun places was just down the creek there . . . After the white people pushed them up this far in the valley."

I looked at the expanse of packed ground. "Well, where is Sarah's grave? There's no marker anywhere."

"Hmm. I don't remember. Somewhere in there, though."

I jumped out and looked around. There wasn't anything to see really. A warm breeze blew, and I could hear the low-running creek below. A lone cow bellowed in the distance.

"I can't see anything," I said, getting into the car.

"Oh," Mabel said, as if I had just mentioned what I had eaten for breakfast.

I looked out at the empty ground. "So this is where it ended for Grandma Sarah Taylor," I said.

Then all at once, Mabel burst into laughter. Not her light chuckle, but loud raucous laughing. She was looking at me sideways. I wondered what I had said or done that was so funny. How was she going to make fun of me this time? Then I heard it.

"No," she said, barely able to contain her laughter. "Grandma didn't end here. She didn't die here. She's just buried here. Who ever heard of a person dying in a cemetery? Well, I guess they could. It's a good idea, anyway. Is that what you learn in the school?"

"No," I answered. I felt angry. She knew what I meant. Then I looked down the creek, and over my shoulder to the highway. The old Wintun village. The dirt road where the highway is now. Grandma Sarah on the wagon with the sickly little girl. Grandma Sarah packing and washing

clothes. The creek. The water that was still running clear from the hills above Lolsel to the big valley down below. Mabel. For the first time all day I thought I understood something she was trying to say. Of course, people didn't die in cemeteries. They died when people forgot them.

I started the car and turned around. We thudded and bumped our way back to the highway. We drove on in silence. It was almost dark now.

After I pulled into the driveway of her new HUD home on the Rumsey Wintun Reservation, I jumped out of the car and turned on her porch light. I wanted to see what was left of my new car. Then I heard her passing on my side of the car. "Car done real good," she said with a slight chuckle. I looked up from the dusty red fender, then took her arm and helped her up the porch step.

Sarah Taylor's Granddaughter

Carnivals, Madams, and Mixed-Up Indian Doctors

Then Mrs. Spencer she tried to put me in school, but school didn't put up with my Dream work.

Mabel might not have been able to cook and clean house. She might not have known about marriage. But she knew how to weave baskets. At an early age she demonstrated an astonishing ability to handle willow rods, sedge roots, and redbud bark. She made small but beautiful coiled baskets. She created anthill and quail designs without ever having seen the patterns before. When Sarah dug sedge along sandy creek beds or cut redbud in the hills, Mabel had energy to help. She worked along with Sarah. She could sit for hours splitting and peeling sedge roots or peeling and coiling redbud bark. On the wagon, she pointed to willows ready for harvesting. "This is good," Sarah said. "You can make money with your baskets." She told Mabel about Joseppa, Daisy's father's mother, who was a great basketmaker and saved the few Lolsel survivors from starvation one winter by trading her baskets to white people for food. But the spirit told Mabel not to listen to Sarah. "You're only doing this because of me," the spirit said. "You listen to what I say."

Which is what complicated things at Mrs. Spencer's.

Mabel kept listening to the spirit. She kept Dreaming. When Mabel fell asleep at the breakfast table, when she hummed out loud in the middle of the night, Mrs. Spencer was right there, holding her, trying to help. But Mrs. Spencer didn't know about the Dream work. She couldn't. Mabel was forbidden to tell.

The first thing Mrs. Spencer tried to do was fatten Mabel up. She put Mabel in a room upstairs, next to her own, and as old as Mrs. Spencer was, over seventy, she ran up and down the stairs with plates of roasted chicken and duck, fresh vegetables, milk and cottage cheese. Mabel ate the cottage cheese. She took buttermilk too, but little else. Mrs. Spencer was divorced; she had lived alone for many years and had made the Indians' well-being her cause in life. She was determined to make Mabel well. When Mabel didn't respond to the heaps of food Mrs. Spencer set before her morning, noon, and night, Mrs. Spencer promptly sought advice. She called her daughter in Yuba City, and her daughter, Alice Whitworth, told her about a Chinese herbalist in Chico.

So off they went, sixty miles north to Chico. It was Mabel's first long ride in an automobile. A ranch hand drove the car and Mabel sat in the back seat with Mrs. Spencer. They went up through Colusa, where Mabel had often ridden with Sarah on the wagon. The same ride went so fast. They stopped in Yuba City to pick up Alice, and then continued on to Chico.

Mrs. Spencer and Alice ushered Mabel into a small house on the edge of town. The place was set up as a doctor's office. The front room served as a waiting room, the bedroom as an examination and consulting room. While they waited, Mrs. Spencer and Alice browsed through books and journals on

Chinese herbs and other kinds of unusual medicines. Mabel had little idea how unconventional the old woman and her tall, straight-haired daughter were at the time. The two women took the opportunity to ask the tiny balding Chinese man questions about this and that as he poked and pushed on Mabel in the examination room. The herbalist answered their questions, then looked up to his tall shelves of bottled herbs and said, "This girl has weak blood. She is not taking enough to eat." He gave Mrs. Spencer an herb, a kind of tea, that she was to give to Mabel several times a day to fortify her blood. "And if all she eats is cottage cheese and butter-milk, give her more of it," he said.

The combination of the tea with added helpings of cot-tage cheese and buttermilk made Mabel fat. She didn't just fill out, she grew stout. A different-looking girl. No longer the emaciated bag of bones, but a portly young teenager who needed all new clothes. But Mrs. Spencer wasn't satisfied. Mabel still fell asleep off and on during the day, and she sang and hummed in her sleep all night. Mabel was fascinated with Mrs. Spencer's electric sweeper, and often she swept the floor with it. But then she would stop, in the middle of what she was doing, and stare straight ahead.

It wasn't until Mabel went to school that she realized how different she was from other children. After Mabel put on weight and seemed to have more strength, Mrs. Spencer en-rolled her in the first- and second-grade classes at the local school. Mabel learned the alphabet, learned to write her name, and how to add and subtract. But after two years in school, she learned little else. More often than not, she folded over her head on her desk and fell asleep. "Don't you want to learn like the others?" the teacher asked her, pointing to the room of eager white faces that were five and six years

younger than Mabel. "Yes," Mabel answered, her eyes heavy with sleep. But Mabel kept drowsing, falling asleep. At lunchtime and during recesses, the teacher put Mabel in the library, where she could sleep, and it was there, seeing the other children through the windows as they jumped rope and played games, that Mabel began to wonder about herself, at least in those moments before she started Dreaming.

The spirit talked to her constantly now. A voice sounded inside of her and all around her at the same time. Sometimes it felt as if her own tongue were moving, shaping the words she was hearing. This happened when she sang the songs that came loud and clear. "Am I going crazy?" she asked once, hearing the voice in the room and feeling her tongue move in her throat. "No," the spirit said, "it's me. And what is happening is that you have an extra tongue. Your throat has been fixed for singing and sucking out the diseases I've been teaching you about. It's talking. It's me in you." "Well, how am I to suck?" Mabel asked. "You'll know when you get to that point. You will have a basket to spit out the disease. All your baskets will come from me. Like I told you. Watch how things turn out." The spirit explained each of the songs that Mabel could hear and sing clearly now. "This is your setting-down song, for when you're calling me. This song is for putting the sickness to sleep. You will have many more songs."

Mrs. Spencer sometimes slept with Mabel. "Are you dreaming? What kind of nightmares are you having that you talk in your sleep all night?" Mrs. Spencer asked and climbed into bed with Mabel to comfort her. She put her arm around Mabel, and then Mabel couldn't sleep. She was afraid that Mrs. Spencer would hear what she was singing or saying to the spirit. So Mabel became more tired during the day. She stayed in her room and watched from her window as the

Carnivals, Madams, and Mixed-Up Indian Doctors

ranch hands worked around the barn and corrals below. She watched the rain, the new leaves and flowers in the spring, the dry, dusty ground in the summer. She knew when the vineyards ripened with dark purple clusters of grapes in the fall, she would see Sarah.

The Indian camp was on the other side of the ranch, across the vineyards from the main house and barn. The ranch hands pitched tents for the Indians and built half a dozen outhouses just beyond the camp. Mrs. Spencer inspected their work before the Indians arrived. She pulled and pushed on the tents, making sure they were sturdy. She checked the outhouses to see that they were clean and that latches were on all the doors. Mabel packed the suitcase Mrs. Spencer gave her and waited until Sarah arrived, which usually was a day or two after Mabel saw the first wagon of Indians on the dirt road, moving into the camp. Sarah was the only Indian who came to the main house, and when Mabel saw her from her bedroom window, she knocked on the window frame, waving to Sarah below, and picked up her suitcase and hurried down the stairs.

It was Mabel's time to visit her family. Not just Sarah, but her mother and her uncles and their families. She found she had a baby sister, named Frances. Old Mateo Lorenzo had died and Harry, his son, was now chief of the Rumsey Wintun. Daisy had status in the tribe as Harry's wife. And Anderson, who had split up with Rosie in Cortina, was married to Ida Lorenzo, Harry's sister. All this must have made Sarah happy; she had wanted her children to marry into the local Wintun tribe. But she still cried with the first light of dawn and, as Mabel found out, she talked more and more about the old days, about Lolsel. "No more of us," she said, looking at her Wintun grandchildren. "No Lolsel."

Mabel and Sarah had their own tent, equipped with kero-

sene lamps, shelves, and two long cots for sleeping. Sarah preferred to sleep on the ground, and Mabel, who had gotten used to a soft bed, sat with her, listening to stories about Lolsel and idle chitchat about Rumsey. When Mabel got tired, she crawled into her cot bed. During the days, Mabel worked alongside Sarah cutting grapes. When Mabel dozed off, Sarah bundled her apron for a pillow and let Mabel sleep under the shady vines.

The early fall days left enough light in the evenings for people to travel to the nearest store or to socialize along the creek, where a lot of the men and some of the women drank wine. Lovers met in secret places in nearby orchards and old people built fires and gossiped about the irreverent younger generations who were forgetting Indian ways. As with every work camp, many different groups gathered together— Colusa Wintun, Rumsey Wintun, Cortina Wintun, Maidu, Sulphur Bank Pomo, Lower Lake Pomo—and they watched and talked about one another.

Mabel rode off with Sarah on the wagon. Sometimes they went to the foothills to gather herbs. Sarah dug angelica from the damp, shady places near springs and along creek beds. She washed the gnarled roots that looked like an old person's fingers in the water and gave them to Mabel. "You still talk in your sleep," she said. "Keep this angelica near you. It will keep away evil things." She asked Mabel about her basketmaking and was disappointed to learn that Mabel had not been weaving. "Keep weaving," Sarah insisted. "You will be rich one day." She showed Mabel baskets she had finished and gave Mabel rolls of willow rod, sedge, and redbud. "Now you have no excuse," she told Mabel. "Make baskets and sell them to the white lady." Mabel said nothing. She only thought how strange it was that, except for the two

weeks she saw Sarah and the family each year, she had no
one speaking Indian to her but the spirit.

As Mabel got older, when she was fifteen and sixteen, she spent less time riding off in the evenings with Sarah and more time visiting people her age. She was interested in other young people, especially since she had felt so lonely and different among the white students at the school. She had her cousins, Anderson's children from Cortina, and other young people to talk to and visit. She listened as the young women talked about clothes and boys and dance halls. She heard about the carnival in Marysville and the state fair in Sacramento. The girls cut and curled her hair in the latest style. Occasionally, she saw a girl withdraw her hand, as if the girl had suddenly remembered something. She also saw the suspicious glances of some parents and other elders. But she tried to ignore them, and she closed her ears when her cousin Marie from Cortina, in an attempt to be helpful, said, "They're weird old-time Indians. They think you're some kind of a spirit person. I think you're just tired a lot, from when you were sick as a kid."

But Marie changed her mind and joined the others. She saw something she couldn't forget. Neither could Mabel. It was late, after almost everyone was asleep, except for the few teenagers who whispered and flirted on the road outside the camp. Marie was walking Mabel back to Sarah's tent. They decided to stop at the outhouses first. So they walked through the camp of tents and on the path that ran along the vineyard to the outhouses. Somewhere there, along the path, Marie stopped and said, "Look." Mabel turned and saw in the full moon over the vineyard what looked like a huge bird flying in place. She blinked, focused her eyes. It wasn't a bird, but a man, arms spread out, silhouetted against the mas-

Carnivals, Madams, and Mixed-Up Indian Doctors

sive ball of yellow light, and he wasn't still, situated in place, but hopping up and down, dropping from his place before the moon to the middle of the vineyard, then shooting straight up again. Before Mabel could turn to her cousin, before either of them was able to say a word, the man landed right in front of them. He spoke to Mabel. "Good evening, young lady. How are you this lovely night?" he said, tipping his Stetson hat. He was a heavyset man, but not fat or too old, maybe in his mid-forties. His clothes were clean and pressed, his creased pants held up by fashionable suspenders. He wore a tie.

"Fine," Mabel finally answered, in shock and not knowing what else to say. She turned to Marie, but Marie was frozen. Urine ran down Marie's legs.

"Never mind her," the man said. "My name is Albert, how do you do?" He extended his hand. Mabel didn't move. He spoke Wintun, which Mabel understood. Yet something about his voice made her think of the spirit. Maybe it was the way he said things, confident, knowing, yet something tricky, half making fun of her.

"You're going to come with me," he said, and he lifted his extended hand and gestured to the sky, where Mabel saw a wagon in the moon. Horses pulling a wagon, riders too, and it was all coming toward her until it was there on the path where she was standing. Horses, like any others, sweating, tossing their heads. And ladies, three of them in fine clothes. One of the ladies was particularly beautiful. Her parted long, wavy hair shone in the moonlight. She was pointing with a long finger to the vacant seat next to her.

"No," Mabel said to the man. "I live with the white lady. She won't let me go. She won't let me . . . No . . ."

The man studied her a moment, then looked over his
shoulder to his wagon. He looked back at Mabel. "OK then.
You'll be dead in nine months." He climbed onto the wagon
and took up the reins. He turned the horses, and Mabel
watched the wagon disappear beyond the grapevines. It
clanked and rattled in the distance, long after she was able to
see it.

Marie ran back to her family. Mabel found her way to
Sarah's tent and fell fast asleep. The spirit began talking, tell-
ing her about a certain song and how one day she would
have a cocoon rattle and a pipe. She would smoke angelica
root in the pipe. "Your grandmother is right about the an-
gelica. It's good stuff . . ."

"Why didn't you tell me your name is Albert?" Mabel in-
terrupted.

The spirit chuckled, then laughed out loud. "Albert is a
man. He's a human being on earth, just like you. Did I ever
tell you I was a man?"

Mabel was perplexed. "But you came . . ."

"I didn't come anywhere. I was there just like I'm here
now. I saw what happened."

"Then who is Albert?"

"A doctor. Like you will be. What do you think I'm train-
ing you for? Doctors can do many things. Already you can do
special things. Look at your baskets. Each one is a miracle.
And the songs growing in your throat . . ."

"What's he want?"

"He knows you have songs. He has spirit power. He knows
about you. He wants to help you, give you some of his songs.
Those ladies are his helpers. They're his singers. But he has
you mixed up with another young woman whom he was told

to help. You and that young woman have a similar spirit. You will have two helpers on this earth. Something, somebody you have seen and this woman he got mixed up with you."

"Well, if he's a doctor and knows about it, how come he got us mixed up?"

The spirit laughed again. "I told you, he is a human being on earth."

"But he said I would be dead in nine months."

"Did *I* say anything about you dying? How are you going to be a doctor if you're dead? What kind of doctor is a dead doctor? You ever hear of such a doctor?"

"Why did he say that? Another mistake?"

"He was seeing that you are going someplace soon, about that time . . . He saw it in your body, the way you are wearing your hair and clothes. Now enough of the questions. Just sleep now. Tomorrow already you will start moving."

In the morning, Mabel told Sarah what had happened. News of the strange occurrence the night before spread through the camp like wildfire. That evening the grape harvest ended. The last grape was picked. People collected their earnings and, rather than partying and waiting until the next morning to move on, they packed and left camp immediately. Sarah went back to Rumsey. Mabel went back to Mrs. Spencer's. As it turned out, Mabel wouldn't be in Mrs. Spencer's camp again. Neither would any other Indian. That winter, when Mabel was almost seventeen, Mrs. Spencer died. She died suddenly. The ranch was sold. Alice Whitworth rushed in, as if Mabel were an abandoned, helpless child, and took her to Yuba City.

Alice's house, which was in town, was not nearly as large as Mrs. Spencer's. Mabel felt cramped. At first she thought it was the small house. But it was Alice, who never seemed to

be two feet away from Mabel. Not in the evenings, as she talked on and on by the fireplace; nor during the day, as she sat or stood sewing wherever Mabel was. She was a single woman, divorced like her mother. As far as Mabel could tell, she did not have children. The house was immaculate, every piece of furniture situated just so. With the way Alice, who was very tall and stern-looking, followed her around, Mabel began to feel as if she were in the way, clutter in Alice's neat house. But it was the bother over Mabel, clutter or not, that Alice preoccupied herself with. She worried about how much and what Mabel ate. She recorded the hours Mabel slept and how long she was awake. In town, she never let go of Mabel's arm and warned Mabel about men's advances and the pickpockets from the carnival across the river in Marysville.

Mrs. Spencer had allowed Mabel the freedom to curl her hair and experiment with new clothes, the freedom to think, to digest and imagine what she had heard from her cousins about young women's lives. Now Mabel felt hemmed in, stifled, and more than ever she grew curious about the world beyond the life she knew with a single white woman. She developed a secret life with quick glances and wild ideas. Walking with Alice downtown, she saw the streetcar with the word C-A-R-N-I-V-A-L on the front that carried people back and forth across the Yuba River. She saw the men who rode the streetcar, dandies in pinstriped suits and gold chains. And the women were like no women she had ever seen, women with ruffles and painted faces who smoked and laughed out loud like men. She pictured herself riding with them, going over the river. But it wasn't until she saw a Help Needed sign that her will matched her desire. "I'm going to Marysville to clean lettuce," Mabel told Alice. "But why?"

Carnivals, Madams, and Mixed-Up Indian Doctors

Alice protested. "You have never worked. I've never asked you to do a thing." Mabel was wearing a plain skirt and she had an apron in a paper bag. "I'm old enough," she said, "I'll be back after work."

What Mabel didn't realize was that it cost to ride the streetcar. She didn't have a cent on her. So that first day she walked across the noisy, narrow bridge to Marysville on the other side of the river. She kept asking for directions until she found the long shed next to the lettuce fields. She was hired and she stood ten hours with only a lunch break cleaning heads of lettuce for packing. She was determined; she never stopped to think that she had never stood, or even stayed awake, that long in her life. She earned money. She rode the streetcar back and forth to work and took in the smell of perfumes and cigar smoke. She worked for two months, until there was no work. But she didn't go back to her quiet life with Alice Whitworth. At the lettuce shed she had met a Yakima Indian girl from Washington, and the girl took her to the carnival.

Mabel didn't only go to the carnival. She joined it. She danced the Charleston for fifty cents a night. Hard to imagine, since I always knew her as an older woman, an elder. From the first time I met her, she had seemed like a grandmother to me.

I was about twelve years old, in junior high school, and I had followed her adopted son, Marshall, home. At the time, I was living here and there with different families in and around Santa Rosa, as I had since I was six. First there was the Murray family who had a dairy. Then Mike and Loretta on the horse ranch. Then the Martinezes, a Mexican family.

Carnivals, Madams, and Mixed-Up Indian Doctors

And all along, the Indians: the Bacas, the Gomeses, the
Smiths.

Legally I belonged to George and Mary Sarris, who adopted me at birth, after they figured they couldn't have children of their own. Only they did start having children, right after they adopted me: three blond, blue-eyed children. George, who drank heavily, became abusive, and Mary let me roam, find other places to live, safe from George. I kept in touch with her, mostly letting her know I was all right, which wasn't always the case, nor could it have been for a kid going from place to place. I didn't know *who* or *what* I was. My birth certificate specifies that my natural mother was white. As to my father, it notes only "unknown non-white." I did not know I was blood-related to many of the Indians I was growing up with. I did not know what had happened to my natural parents, except that my mother was dead and that she was young when she had me. I didn't know anything. Sometimes I wondered if I was Mexican. Maybe Indian. Black possibly. Maybe the race issue played into my problems with George Sarris. I don't know.

When I walked up to Mabel's neat white house with yellow shutters that afternoon, I was thinking only of a place to hang out, spend a few hours until it was dark, when I would make my way back to town, to the pool halls and old hotels on Lower Fourth. I was a good talker—a skill essential to my survival. Talk and charm, make myself familiar where I was unfamiliar. Eat. Sleep. Stay awhile or move on. But Mabel stopped me. I saw right away that she was Indian. I should've figured as much since Marshall was Indian. She was sitting at her kitchen table with a friend, an Indian woman about her age, who was introduced to me as Mrs. Parrish. I immediately started talking about all the Indians I knew, but I found

Carnivals, Madams, and Mixed-Up Indian Doctors

myself talking only to Mrs. Parrish, who listened patiently with a slight smile. Mabel had gotten up and moved to the other side of the kitchen, and when she came back she placed a peanut butter and jelly sandwich and a glass of milk on the table. "Now sit down," she said. She hadn't heard more than five words of what I had said about the Smiths or the Penas or the Gomeses. And she didn't care to. I could tell. I sat down.

The two women talked as if I wasn't there. They spoke in English, something about a sacred mountain, which made no sense to me. I was quiet now, listening, and I ate. I had forgotten how hungry I was. Marshall had disappeared someplace, so I was left alone with the two women. Mabel seemed old for being my friend's mother, even with her dyed black hair. She was small, not nearly as large as Mrs. Parrish, who was not only heavier but taller. And she was perfectly dressed, her clothes spotless, a wristwatch placed just so below her buttoned sleeve. She sat as if she could be anywhere, in a restaurant uptown or on the bus, just as easily as at her own kitchen table in the small house on Robles Avenue on the outskirts of town. There was something effortless about her order and control, in the way she placed the sandwich and glass of milk on the table, in the way she silenced me.

Suddenly, Mrs. Parrish turned to me and said, "You be careful of those Indians." She mentioned certain names and said she knew them well. "They are my relations," she said. "They'll get you in trouble. You're lost, running crazy, and that's when a person is weak."

I looked across the table at Mabel, who had picked up a coil of roots I had seen other older Indian women use for basketmaking. She set the coiled roots down and sighed. She

Carnivals, Madams, and Mixed-Up Indian Doctors

looked across the table at Mrs. Parrish. Both of them, I thought. Both of them are alike.

"Do you want more milk?" Mabel asked with a small laugh. Then, before I could answer, she nodded to the refrigerator. "It's there," she said.

My Indian friends told me that Mabel and Essie Parrish were Indian doctors. Some friends said witch doctors. They said the women could cast spells on people. Others said they were good and told stories about how one or both of the women helped their relatives. "Mabel sucked like a goldfish out of my aunt." "My cousin was possessed by a demon, and those two ladies tied him to the centerpole in the Roundhouse so he would be still and then cast the demon off." All kinds of stories that seemed unbelievable.

I wasn't interested in spells and such things then. I was respectful of Mabel, and appreciated her kindness and caring. And the fact that I had to stop my crazy talking, my fears and insecurities when I was around her. She always seemed at least one step ahead of me, and in her presence, where I was quiet, I felt peaceful, relaxed, even as she kept me alert, on my toes. She talked, told me stories about places and people she knew, stories I would hear over and over again. The stories seemed wild, unusual at times, but sitting there at her kitchen table, even at the age of fifteen or sixteen, I knew what it was like to have a mother who cared enough to tell you stories.

When I was sixteen I bought my first car, a 1959 two-door Ford. To support the car I had to take a job in a local restaurant as a busboy. I was separated from my friends and the pool halls. I saw my friends' parents working in the restaurant as dishwashers and waitresses. I figured things wouldn't

get any better for me. So I decided I would get rich. I bought into the Horatio Alger story. I was a junior in high school and suddenly found myself struggling to make up for the years I barely stayed in school. I managed. Mary Sarris had divorced George, and I went back to the Sarris household, where I had a regular place to study. And study was what I did, with the hope of going to the local junior college.

After I could drive, Mabel and I took many trips to pick herbs or dig sedge along Dry Creek, just north of Healdsburg. She prayed, sang songs, told stories. She laughed at me when I told her my ideas about making money. "That don't mean nothing," she said. Much later, after I had gone to the junior college and transferred to UCLA, I told her that I wanted to be a writer. I told her all the things I wanted to write about. She listened and usually chuckled. "That's a cute story," she would say, even after I outlined the most dramatic tale imaginable. Sometimes I drove her to demonstrate her basketweaving to groups of housewives or in large university lecture halls. Her baskets are beautiful, stunning coiled baskets in different shapes and designs; feather baskets, unlike any seen before, made from the bright yellow feathers of the meadowlark, the metallic green feathers found on a mallard duck's neck, and the orange breast feathers of the robin. And miniature baskets, some no larger than an eraserhead, so small you have to use a magnifying glass to see the intricate design made from the tiniest strips of redbud bark. She had become famous for her baskets, and she was always perplexing to those who wanted to know about her. Her seemingly flippant answers and all that talk about the spirit baffled people.

I was used to her ways by then. Not just when she was answering questions before an audience, but when I was

Carnivals, Madams, and Mixed-Up Indian Doctors

alone with her in her home or on the road someplace. Anything could happen. Strange things that seemed to happen only with Mabel.

I remember one winter night when I was home from UCLA for Christmas vacation. She asked me to drive her up to the Kashaya Reservation to see Mrs. Parrish, who was not feeling well. It was a Friday night, and I was not happy at the prospect of taking that long, treacherous drive up Highway 1. I had wanted to visit old friends of mine in town. I obliged Mabel, only to find my worst fears about the drive up the coast at that time of year to be true. The road, with its twists and turns and five-hundred-foot drops to the ocean below, was dangerous enough on a clear summer's day; that night, it was covered by fog. I couldn't see ten feet in front of me. I was impatient, angry. Driving along at about ten miles an hour, I thought longingly of my friends in town. Mabel kept talking, saying something about this or that. Then she said, "I once knew this woman who had a fog song. I think I remember it."

Oh, yeah, I thought to myself. Why don't you sing it?

"It goes something like this," Mabel said. And then she sang a song that was soft and low sounding. The fog lifted, a tunnel led on clear to Stewart's Point and up Skaggs Springs Road to the reservation.

I still don't know what the urgency was surrounding the trip, if there was an urgency. I thought maybe Mabel was going to doctor Essie. But that wasn't the case. Essie was staying in the old reservation schoolhouse. I remember her daughter Violet was there, and some other family. She was in a part of the large one-room building that was partitioned off with bookshelves. She was in bed, but she did not look sick to me. She was gray, she looked older than when I had seen

her last, and perhaps thinner. But she seemed well. Mabel sat in a chair next to the bed and began chatting with her about how she felt. I went back to the open room and tried to make conversation with Violet and the others, who I had seen briefly years before on my visits to the reservation with Indian friends from town. No one remembered me.

Then I guess I heard Mabel call. Something happened so that I found myself behind the bookshelves with the two women again. I stood there wondering what Mabel wanted. She was talking to Essie just as when I had left her. All at once, Essie broke out of the conversation and looked up at me. "You jump around too much," she said. "Sit down." She was patting the bed with her hand. I sat down. "You listen to what it is we are saying," she said. "It is important what we say."

"Yes," Mabel echoed.

But when they started talking again, it was about some woman and whether or not a certain young girl was her daughter. They talked on, idle talk. I didn't see the point. And I don't remember much else, until Mabel and I got back to Santa Rosa that night. It was late, four in the morning, and I was exhausted. I walked Mabel into her place and was on my way out, back to Mary Sarris's, when Mabel started talking. "Now you listen to me," she said. "This is what I'm saying, what Essie was talking to you about. This has rules. It's your life." She opened her hand, and in her palm I saw a tiny basket attached to a small woven pouch with a safety pin. She pinned the basket on my shirt, saying, "For when you are on the road, amongst the crowds. Who you are. There's rules and there's more to it, which you'll know."

One night Mabel told me straight out how she danced as a flapper. That and all the other things she did on her travels with the carnival.

It was in early April, the spring after that hot fall day I had driven Mabel to Stanford. Spring 1988. I was completing my doctoral coursework at Stanford. I decided to write Mabel's book as my dissertation. A little pressure from school might get the job done.

That spring, with time finally to finish interviewing Mabel and tie up loose ends about the details of her life, I found myself spending less and less time with her and more and more time with two women I didn't know. Violet Chappell, Essie Parrish's daughter, and Anita Silva, Essie's niece. It was a crazy time. The three of us made countless trips, adding thousands of miles on my new Honda Civic, going from Stewart's Point on the coast to Rumsey in the Sacramento Valley and back. We were looking after Mabel, finding her an Indian doctor and checking to see if she was getting along all right.

Her condition had worsened. During the fall, she had been in a lot of pain. By spring, she was in and out of a wheelchair. It wasn't just her wrists that were terribly swollen now, but her knees and ankles. She looked thin, weak, though she did her best in front of visitors. She kept her hair dyed and permed. Her clothes, which looked too large for her now, were clean, pressed. "It's catching up with me," she told me time and again. She mentioned the menstruating girl she had doctored as the cause for her condition. And she talked about an old man she had refused to marry ten years earlier. "Maybe he poisoned me," she said. "They tell me he was that way." She was speculative, unsure, which seemed to

me so unlike Mabel, especially about matters of her own life.

I suggested we find an Indian doctor to help her, and I mentioned Salome Alcantra, a Pomo medicine woman Mabel knew and had helped years before. Mabel thought it was a good idea. So I called Salome and explained the situation. "Yes," she said. Her voice was very soft. I could hardly hear her, and she gave me directions to the Yokayo Pomo Reservation, where she lived, as if I was intimately familiar with the landscape outside of Ukiah. She mentioned barns and trees, a large rock, something about a state mental hospital lately turned into a Buddhist temple. She couldn't tell me the names of roads. "I don't know how to get there," I told Mabel over the phone. "Call Violet," she said. "She knows how to get there. Go get Violet."

Which is what I did that early spring morning in April, and which is how the traveling back and forth through Sonoma, Mendocino, Lake, and Yolo counties started.

I arrived at Violet's place on the Kashaya Pomo Reservation at nine o'clock in the morning, about an hour later than we had planned. Luckily for me, she was not waiting. She wasn't ready. Her husband, Paul, a tall white man, about sixty, in Levi's and a white T-shirt, greeted me at the sliding glass front door of their extra-wide trailer home. He stepped aside and gestured for me to sit down at the long kitchen table. He poured me a cup of coffee. "Violet will be right out," he said, and his large, chapped hands delicately set the overflowing hot cup on the table.

I glanced at the numerous pictures hanging on the walls. Family pictures, nieces, nephews, cousins, but mostly pictures of Essie, Violet's mother. Essie in front of the Roundhouse in a beaded buckskin dress. Essie in the Roundhouse wearing a dark, floor-length gown sewn with abalone pen-

dants and holding in each hand a medicine pole, as tall as she was and covered with figures of stars and crescent moons. Essie leaching acorn flour in the old way, in a mound of sand. Essie weaving baskets. Essie with Sid, Violet's father. Essie with Mabel. If only she were alive, I thought. If only Essie, who had passed away nearly ten years ago, could help Mabel . . .

The sliding glass door opened and in walked Anita, Essie's niece. "Gee," she said out of breath, "I thought I was late." She turned to me. "Do I know you?" she asked. She was dark and heavyset, and somewhere in her mid to late fifties. She was bold. I told her I had seen her years ago on the reservation, when she had a horde of children.

"Hmm," she said and sat down. "What's your name?"

I told her. She thought a moment. "Don't know it," she said. Then she looked up to Paul and began running the palm of her hand back and forth over the flower-print oil-cloth that covered the table. "This," she said to Paul, continuing to roll her hand with its extended fingers, "means I want coffee." The coffeemaker burped. "And that's a sign it better be quick." She laughed heartily. "I'm usually not this bad," she whispered across the table to me, "I'm worse. Hah!"

We laughed. Paul set her coffee on the table. She lit a cigarette, and with her free hand adjusted the loose-fitting blouse over her ample front.

"Vi's getting ready?" she asked, exhaling a cloud of smoke.

"I'm right here," Violet said, stepping into the room. She and Anita looked like sisters, only Violet was smaller. "This hair, it's not dry. Have to dry on the way, I guess." She patted at the row of pink curlers on her head, mocking a woman primping. "Gee, I sound like a white woman, don't I?" she said and hissed between the spaces in her teeth.

Carnivals, Madams, and Mixed-Up Indian Doctors

Violet smoked too. Both of them. Never mind the open green hills, the pastures with patches of purple lupines and golden poppies. My eyes were so sore from the smoke, even with the windows down, that I could hardly keep them open just to see the road in front of me. Even Mabel's smoking hadn't prepared me for a ride with these two women. A ride about four hours in each direction.

We drove down Skaggs Springs Road east from the reservation, then went north on Highway 101 to Ukiah. The women talked back and forth to one another in Kashaya. I listened to the throaty sounds of the language. I knew bits and pieces of Kashaya from the Indian friends I knew in my youth. A couple of times I figured the women were talking about me. Something about me and Mabel. Then Violet began talking from the back seat in English. She talked about her mother, telling many of the great things her mother had done and taught her, as if she were giving me a partial résumé of the woman. ". . . Oh Mom, she taught even about how to take care of your body. Everything. She told us how to sit, how to act like ladies. Everything to respect yourselves. And she told the reason why. She explained things why. You keep your knees covered when you sit down because men get ideas. She even taught about sex. 'Sex is a beautiful thing,' she said. She gave us teachings. But now, oh, the younger generations, the girls just run around, take off their clothes any old place, whatever. They have no respect for their bodies. Heck, I hate to say it . . ." She paused. ". . . but they act like white women. Well, I just had to say it, Greg. That's how we Indians see it."

I had news for her. I wasn't white. Well, half of me wasn't. Even with my fair skin and blue eyes. And more than that. I had found out I was Indian. Indian from right there in

Sonoma County. My father, Emilio Hilario, was half Filipino and half Indian. His mother, my grandmother, was Coastal Miwok and Kashaya Pomo. I wanted to blurt out the whole story. But I didn't. All their talk in Indian and Violet's "*we* Indians," whether meant to exclude me or not, unnerved me. I was a twelve-year-old kid again. I began talking about the Indians I knew, the people I grew up with in Santa Rosa. Anita, who worked in the Sonoma County Indian Health Clinic, mentioned that she knew many of the same people. She worked with one woman I knew and liked her very much.

Violet clicked her tongue in disgust. "Greg, I don't know how you know *those* people."

We stopped for a hamburger in Ukiah, a small town sixty miles east and north of the Kashaya Reservation. Sitting at a bench outside the Foster's Freeze, we continued talking about Indians in Santa Rosa. Anita and I talked. Violet listened, until, all at once, she snapped, "Oh, *those* people! Greg, you know all the gutter snipe, the lost Indians." She picked up a french fry and then held it between her teeth, cooling it with quick short breaths.

"I'm related to lots of them," I said.

"Oh my," Anita said, setting down her hamburger.

Violet still held the french fry between her teeth.

Nothing more was said then.

As it turned out, Violet did not know how to get to Salome's. Neither did Anita. We drove in circles for hours around the countryside outside of Ukiah looking for the Yokayo Reservation. Finally, a farmer on a tractor alongside the road gave us directions. After we had driven up the narrow wooded reservation road, we came to a house and asked a woman there for directions to Salome Alcantra's place.

Carnivals, Madams, and Mixed-Up Indian Doctors

Salome was like her voice, soft, a most gentle and kind woman. She looked to be in her late seventies. She was gray, a bit hunched, and she carried a small brown-and-white checked old suitcase. Without knowing any of us, she talked openly, telling stories and pointing to places along the road. "That's Shokadjat," she said, pointing to a creek bed. "That's where our village used to be." Violet and Anita, both in the back seat, said something in Kashaya. Salome giggled. "My language is similar," she said. "You said you need to go to the bathroom."

We drove east from Ukiah, over Highway 20, into Lake County. Violet and Anita fell asleep. Salome looked out the window. Highway 20 goes through the Potter Valley, just before Clear Lake. I thought of Yanta Boone, Mabel's father, who had come from Potter Valley. Potter Valley Pomo. They were called the Red Earth people. Poomo, red earth. Linguists and anthropologists took the word and used it to group together all the peoples of the area who spoke related languages. Pomo. I looked at an orchard and a field of white-face cattle. Where was the Red Earth village? I wondered. Had Daisy ever come with Yanta to Potter Valley? She must have. It wasn't that far from Nice, where Yanta worked and where Mabel was born. Stories. Stories. Stories. Stories.

Somewhere just beyond the lake, Violet woke up. She started talking about her mother again, about all the things her mother had taught her. She was still talking as we dropped out of the hills and into the valley. I felt she was talking as if I knew nothing about Dreaming or Indian doctors, as if I didn't know Mabel. "Mabel and Mom are the same," she said. I felt like saying, what about Salome, who is sitting right in front of you. I thought of suggesting that her hair was dry now and that she could take out her pink foam curlers.

Carnivals, Madams, and Mixed-Up Indian Doctors

We crossed a cattleguard and drove up a paved road to the row of new HUD houses on the Rumsey Wintun Reservation, where Mabel had lived since she left Santa Rosa a few years earlier. Her house, number 105, was like the rest, tan colored and square. Her sister, Frances, answered the door. Mabel sat at her kitchen table in a wheelchair. The chair arms were wrapped with towels to give Mabel's swollen elbow and wrists some cushioning. We visited, made brief introductions, and then Frances and her grandson, Bill, a young man about twenty years old, helped Mabel out of her wheelchair and down the hall to her bedroom. We followed.

Salome was not a doctor like Mabel or Essie. There was not the long formal ceremony with songs and dancing. Salome did not take anything out of Mabel with her hands or mouth. And she could not diagnose illnesses. She wore a small feather headdress, and she ran a clam-disc necklace and a basket with a star design over the length of Mabel's body on the bed. And she sang several beautiful songs. "This is all I have," she said to those of us seated around the bed. "These things and my songs. Spirit give me things and my songs late in my life. Not like other doctors. I don't have so many rules. The songs, they just come. I don't know."

Mabel seemed better. During dinner after the ceremony, she laughed and talked. Salome told about the time she was a young woman and ran away from a school in Oakland where Indian girls were trained to be maids. "Yeah, I hopped a boat across the water to the other side of the bay. No bridges then. And I was walking all the way to Ukiah. Then a police pick me up in Novato and put me on a bus home. Yeah, I hopped a boat. Hid on it."

"That's nothing," Frances said, pushing herself closer to the table. "This lady here, she hopped a train, rode all over the countryside on it. She danced in the carnival."

Carnivals, Madams, and Mixed-Up Indian Doctors

All faces turned to Mabel, who chuckled. "Yeah, I did," she said. "And that's not all."

"Oh, Mabel," Violet said, astonished.

"What happened?" I asked.

"Well, how it happened . . . Oh, Greg," she said, stopping herself in mid-sentence. "This is part of the story. You got your recorder?" She started laughing, her eyes bright behind her glasses.

I sat there. I didn't say anything, not even no. If I had halfway convinced anyone that I was an Indian, how could they believe me? Anthropologists, white people, carry tape recorders, for godsakes.

Mabel caught her breath and cleared her throat. "What it happened was that girl from Yakima, the one I met cleaning lettuce, she says, 'Want to come to Washington with me?' I say 'OK, but how we gonna get there?' "

"Did you understand her language?" Frances asked. Frances's eyes were wide open, her eyebrows arched with curiosity. Even though she had heard the story before, she was still fascinated. She was a quiet woman, reserved, hardly as worldly as her older sister.

"We speak English," Mabel answered. "I lived with white people four years or more. I talk English good . . . Anyway, oh, before that it was the carnival. I forget. We're going there sometimes in the evenings after work. We spend my money on account I'm living with the white lady free . . . " She stopped and looked at me. "Greg, you got that recorder in the car? I'm waiting for it."

Now I had to get the tape recorder. What else could I do? When I came back into the house from my car, I found Anita and Violet bent close to Mabel, listening to something she was saying. They straightened before I could hear what they

were talking about. Were they talking about me? Why all
Mabel's fuss about the tape recorder when in the past Mabel
couldn't have cared less about it. She often made fun of me
for using it, for not remembering on my own. I sat down and
turned on the machine.

"Is it going?" Mabel asked.

"Yes."

"OK, how it happened we go to the carnival, and this girl,
she knows lots of people there. She worked there before, but
she never told me that. She tells me that when lettuce stops.
She says, 'We can get job at the carnival.' I say, 'What?' She
says, 'Doing the Charleston dance.' Then I say, 'I don't know
nothing about the Charleston dance.' 'You wanna learn?' she
says. 'I could,' I say. 'I'm not fat anymore. I'm trim from
working.' 'Yeah,' she says."

"Then we go to the boss. 'Mabel wants to learn the
Charleston,' the girl tells him. Well, I seen it before. I watch
it when I go to the carnival with that girl. I just never imagine
myself that way. But I could, I'm saying to myself. So I learn
how to do it. Then they give me this dress . . ."

"Like a flapper dress?" Anita asked.

"Yeah, something like that, I guess. It's showing my legs."
Mabel chuckled. "Anyway, I dance like that every night
before the crowd. Five times I dance, me and the other girls,
and I get fifty cents a night . . . Well then, the carnival it closed
down for the season. 'Now what we gonna do?' I say to this
girl. 'We go to Portland with the carnival,' she tells me.

"So that's how I took a boat ride. We go from San Fran-
cisco somewhere up to Oregon. Oh, I never been on a boat
and I got terribly sick. I thought I was gonna die. Then in
Portland I dances a short time, few weeks maybe. Then the
carnival it moves again. Someplace, I forget.

"That's when this girl, she says, 'Mabel, you want to come home with me?' 'Where you live?' I ask. Then she tells me Washington. 'How we gonna get there?' She says, 'The train.' So I start hopping the trains, only I don't know about it.

"We go to the train station. We're looking around. Then the Bull, he catches us. What I mean, Bull, the man who watches the trains. He makes sure everything goes good or right or whatever. He says . . . He knows what we're gonna do, so he says 'OK, what you girls are waiting to do I know.' But then he helps us. He tells us about it so we don't jump off too fast and get caught under the train. So me and that girl ride the boxcar to Seattle.

"She got family there, her mother and father. Some others too, I guess. We visit around awhile. Then she wants to visit her grandmother on the reservation. Yakima. So we go there and eat apples along the way. Big red apples, like I never seen. Windfall, the ones on the ground. Farmers let you eat those . . . Anyway, her grandmother, she's glad to see her. She cooks good for us and we rest up there. We stay about two weeks, then come back."

Mabel looked down and put both her hands around her half-filled coffee cup, as if she were warming them.

"Come back where?" I asked.

"Yuba City."

"How did you get back?" Violet asked.

"Hopping the train, probably," Frances answered.

"No," Mabel said. "The bus. Girl's parents give us money for the bus."

"So you came back to Alice Whitworth's," I said.

"Yeah. She was glad to see me, even I was with that Yakima girl. She didn't want me leaving in the first place. She felt real badly. So did I."

Carnivals, Madams, and Mixed-Up Indian Doctors

Slowly and unsteadily, Mabel lifted the coffee cup to her mouth with both hands and took a sip. She swallowed, took another drink, then set the cup down.

"But I took off again," Mabel said, laughing.

"Oh?" Anita asked, then remarked, "I like your stories, Aunt Mabel." Violet was quiet, smoking.

"Yeah, I take off again. To San Francisco. Me and that girl. 'Oh, no,' Alice says. But I go anyway. But somewhere there in San Francisco I lose track of that girl. I meet another girl, the one wears pants. Not too many womens wear pants then. There's a carnival in San Francisco. Me and this pants girl, we go there and ride the ferris wheel. We take the streetcar after I'm done with my work.

"My work is washing dishes in a Japanese restaurant. Geary and Fillmore streets. Fifty cents a day and food. I have a room by there. Ten dollars a month. Anyway, this girl, she's the one I go around with. She takes me a lot of places, see things. And she don't let the mens talk smart to her. She's the one takes me to see the strip poker."

"Oh, my, strip poker," Anita cracked with enthusiasm.

"Yeah, listen to this," Frances said.

"Yeah, I go with that girl and I seen them playing. Mens and womens together. They keep playing till everybody got their clothes off. Except the winner. Winner still got something on, gets to look at all the people naked."

"Was it like in a room?" I asked.

"Yeah, upstairs in a big house."

"What kind of people were they? White?"

"No," Mabel said, looking over her glasses at me. "All kinds. Black. White. Mexican. All kinds of people. I knew all kinds of people then. There was all kinds of naked people."

"Yuckee," Violet said.

"What did you do?" I asked.

Carnivals, Madams, and Mixed-Up Indian Doctors

"Nothing. Watched . . . Oh, then I got job babysitting during the day, and that's how I got a job at the house. By house I mean where the girls are . . ."

No one moved. You could've heard a pin drop.

". . . Yeah, what it happened, that lady I babysit for she knows head lady at that house. She say to me, 'Mabel, you want better job than taking care of my three kids? I know where you can make five dollars a day.' 'What I have to do?' I ask. Then she says, 'You clean. You do chores around the place.'

"So I go there and the head lady, she says, 'Do you wear lipstick?' And I says, 'No, I'm just the way I am.' 'OK,' she says, then asks if I got a boyfriend. 'No,' I say. 'Well,' she says, 'somebody got to bail you out when the police comes.' I don't know nothing about the bailing out. I just say 'OK.'

"Then I seen them girls. Young girls, nineteen or younger, all of them. They is sitting around, walking around in their nightclothes. Just like that. Middle of the day. But I don't think nothing. Head lady show me how to clean, what to do. Then I'm carrying hot water all the time and towels. 'Just leave it outside the doors,' the lady tells me. Then I'm thinking, what are they using all this hot water for?

"Well, I found out about the bail. That lady, she shows me a trap door. 'You run down here when the police raid,' she says. 'They raid sometimes to make things look good, but it's OK.' That scared me. I don't want no police raid. I talk to the girls working there. I'm friendly with them now. Sometimes I serve them drinks when they're in the front room talking to the men that come in. Anyway, they say, 'Mabel, don't worry about the raid.'

"But I'm not trusting them. I quit. Then they get sad. 'We're gonna miss you, Mabel,' they is saying. And they give

me clothes, all them kind of things they wear. And the head
lady, she tells me, 'You come back whenever you want.' "

Mabel stopped talking and started laughing out loud.
"Then it happened later when I come back here I still had
them clothes with me. Clothes from them girls." She looked
to Frances. "Grandma was visiting your Aunt Ida. Anderson
was with her then. I found Grandma here on the reservation.
I guess I fell asleep. I don't know. The next morning I seen
Ida and them others there went through my things. All them
ladies is walking around outside in them clothes, even they
don't fit."

"Gee, how did they fit?" Anita asked, laughing. "You
know what size *we* are?"

"My head hurts," Violet said. She puffed her cigarette, then
suddenly dropped it in an ashtray on the table. "My curlers, I
forgot to take them out." She laughed and covered her
mouth with her hand.

Bill, Frances's grandson, lit Mabel a cigarette and handed
it to her.

People talked back and forth, gossiped. Then someone
said something about strip poker.

"Oh, they used to play that even in Ukiah, when I was
young," Salome said, giggling.

Anita rubbed out her cigarette in the ashtray then sat back
in her chair. "Hmm. Makes me think of that joker who took
me under the Healdsburg bridge. Remember that, Vi? Shit,
Mamma even made me a dress for that date. I was *so* excited.
We get under the bridge . . . Shoot, not even a hamburger or
a soda first. He says, 'Take off your blouse.' So I did. 'Now
take off your skirt.' So I did. 'Now take off your slip.' So I
did. Then I start thinking, this *is* boring. So I said, 'Take off
your shirt.' So he did. Then I said, 'Now take off your pants.'

Carnivals, Madams, and Mixed-Up Indian Doctors

So he did. Then I don't know what happened. He took off his shoes or something and then jumped on me. Well, I was startled. This isn't romance, I thought. I pulled that sucker out of the car and beat his head against a rock. God, I thought I killed him. He was knocked out. Here I was in the dark in my underwear going to the river and cupping water in my hands to pour on his head. Finally, he came to. 'Take me home,' I said. Then I get home and Mamma says, 'Well, dear, how did it go?' 'Mother,' I said, 'it was *very* disappointing.' "

"Well," Mabel said right away, as if not to be upstaged. "I played the strip poker." She set her cigarette in the ashtray. "Yeah, me and the girl in the pants. They say, 'You girls want to play?' We say, 'OK.' Then I start losing. Pretty soon I have nothing on 'cept my underwear. I'm sitting like this." Mabel crossed her arms over her chest. "Like that I done. Then I lose my underwear. I'm still sitting like that, trying to hide myself. Then they say, 'No, you got to stand up and show yourself, what you are, your whole body.' "

"What did you do?" I blurted without thinking.

"What do you think?" she quipped. She took a puff off her cigarette, then set it down. "I was still trying to cover myself with my hands, but it was no use. 'Put your hands down,' they keep saying. 'Put your hands down.' Then I did."

Mabel without clothes in front of a room full of strangers. I couldn't think of it. I don't think anyone else could either. They laughed nervously, then quickly filled the room with small talk. "Now turn off the recorder," Mabel said. We chatted a while longer, then left.

It was about one in the morning when we crossed that cattleguard and headed north on Highway 20. "Oh, my darn head," Violet said, unpinning the curlers in her hair. "Should

leave the darn things in my hair till tomorrow, but I can't stand it."

"That's not good for you," Anita said.

"I know. But, gee, I set my hair for nothing. I'm gonna sleep on it tonight and it will be all flat in the morning."

"It's morning already," Salome said.

No one talked about Mabel, about her condition or her stories. Salome watched the road quietly. Anita fell asleep. So did Violet after she got the curlers out of her hair. There was no talk of Essie. Nothing about good or bad Indians. Which ones were drunkards. Which ones were found or lost. Who we knew or who we didn't. Before Violet fell asleep, she thanked me for driving. "You're good to Aunt Mabel," she said. Then a couple of hours later, when I braked for a raccoon in the road, Violet stirred and said, "Greg, you're part of the gang." Her voice wasn't sleepy, though she was half-asleep when she spoke. It was straight, definitive, as it had been on the way to Mabel's that day. I put up my guard. The gang on Lower Fourth in Santa Rosa, I thought. Then I thought of Mabel in that room full of strangers. I heard voices saying, "Put your hands down."

Carnivals, Madams, and Mixed-Up Indian Doctors

Medicine Woman

Then I seen Essie. She was the one in my
Dream, the one in the white dress. I knew
about it. It turned out true what the spirit
said.

"But I keep on Dreaming," Mabel said that night in April. "During that time on the train, in San Francisco, my Dreaming don't stop. That's what bothered me. I couldn't get away from my Dream."

After she left the brothel, Mabel took a job caring for a woman who smoked marijuana and drank wine. "Another babysitting job," Mabel said. The woman was married to a banker. Mabel soaked the hemp leaves in wine then dried them in the oven. She rolled cigarette after cigarette and gave them to the woman. Then Mabel caught the woman as she fell to the floor from too much smoke and red wine, and she made a bed for her with a pillow and blankets right there. The banker didn't expect Mabel to lift her. "Have whatever you want," he told Mabel. "There's wine, whiskey, whatever." "How I'm gonna drink and be falling around when I'm supposed to catch her?" Mabel asked.

She kept her job washing dishes at the Japanese restaurant. She worked there seven nights a week. She kept busy.

Sometimes she fooled herself by keeping busy, as if busy was all that she was. The Dream didn't stop. She couldn't stop the spirit when she slept. Then she got tired all the time. The strength she had to work long hours left her just as quickly as it had come that first day she stood for hours cleaning lettuce. She fell asleep on the floor next to the banker's wife. She couldn't hold her eyes open to wash a single teacup.

So she went back to Rumsey with the clothes from "them girls" and found her grandmother at her Uncle Anderson's place on the Rumsey reservation. Sarah saw Mabel was sick. She left Anderson's, where she had been visiting, and took Mabel back to the small house behind the storekeeper's barn. Sarah set Mabel on a couch, and Mabel fell fast asleep.

"Now you've had enough running around," the spirit said. "You did that for a reason, for your work. It was me allowing you to do that. You forgot that. Now you're going to start your doctoring. If not, you'll sleep, you'll stop living . . . You will do what you were put on earth to do, what your life is for. That's all."

Mabel slept for days. Sarah couldn't wake her. It was hot, summertime in the valley, and Mabel was feverish. Sarah prayed. "Oh, if my father was living you wouldn't be like this," she kept saying.

Then, in the middle of a hot afternoon, Mabel heard the screen door slam. She opened her eyes and saw a humming-bird fly in. It hovered over her. She saw that it had the face of a man. "Hello, Mabel," he said. He introduced himself, telling her his name. "You've seen me before. I've been follow-ing you, hiding here and there. Spirit told me to watch you until you were ready."

"Where did I see you before?" Mabel asked, uttering her first words in days. She squinted her eyes and studied the

Medicine Woman

man's dark wrinkled face. She was certain she didn't know him.

"When you were little I came and took you to a cave where an old woman ground poison on a red rock . . ."

Mabel nodded, remembering the small colorful bird that appeared before her on a willow branch while she sat by the creek waiting for Sarah. A hummingbird, she thought, looking up at the scarlet throat and metallic green body of the bird flying in place above her.

". . . Yes, and you refused me . . . You need to know about the poison and lots of other things. You're ready now to become a doctor. So now it's time. You need someone to help you with things on earth. So here I am. Will you accept my help now?"

"Do we have to go back to that cave?"

The face grinned. "No, not now. You'll go there later. You can go with the spirit." He paused, then asked again, "Will you accept my help now?"

Mabel looked at him and then around at the empty room. Sarah was out working. It would do no good to scream, as she had when she was a child. Besides, she couldn't scream if she wanted to. She felt something moving in her throat, words forming, echoing in her. She knew she had no choice but to accept the man's help. "I'm gonna die otherwise," she blurted out.

"Is that a yes?" he asked.

Mabel looked up at him. "Yes," she said.

"Good," he said. "But listen, I'm in a little trouble with the law. I'm in the county jail. But don't worry. They're letting me out after six o'clock tonight. So I'll come for you then."

"Yes," Mabel said, and then watched as the bird spun in the air and flew out the screen door.

Medicine Woman

When Sarah came home that evening, she found Mabel
sitting up on the couch. Seeing Mabel with her hair combed
and in fresh clothes, Sarah felt relieved. She felt she was too
old to worry now, that she couldn't carry on the way she had
when Mabel was a child. It took all her strength just to keep
up with the white people's clothes. How could she care for a
grown woman who couldn't care for herself?

"It's not what you think," Mabel said, seeing the joy and
relief in Sarah's face. She was speaking Wintun, which made
Sarah curious.

"Who have you been talking to?" Sarah asked in Cache
Creek Pomo.

"This man who's going to doctor me," Mabel said, and she
told Sarah the story.

"Yes, that's the Wintun man," Sarah said, "from up north
someplace. But some people say he's poison."

Mabel shrugged her shoulders.

"No," Sarah said. "I'm going to ask around about him first.
Your mother knows of him from when she lived in Colusa.
I'm going up the road to ask her right now."

But Sarah met the man in the doorway. Just as she opened
the door to leave, there he was. He took off his hat. His dark
face was wrinkled.

"Mother," he said, honoring her, "I've come to help your
daughter."

Sarah looked at him suspiciously.

"Listen," he said, gesturing over his shoulder, "I have a
new Ford there and it runs real good. And I haven't been
drinking. I swear it. I just got out of jail." He waited for an
answer, then said solemnly, "Your girl there needs help."

Sarah turned to the couch, but found Mabel standing right
behind her. Mabel didn't say anything. She walked past

Sarah and followed the man to his new black car. The man turned and bowed courteously to Sarah, who stood unblinking in the doorway. Then he opened the car door. Mabel got in and sat between two older women in the back seat. A small, younger man sat in the front, next to the wrinkled old man.

They drove for a long time. When they stopped finally, it was dark. They were somewhere in the hills, and when Mabel got out of the car, she saw a small group of people waiting by a dirt path. She didn't recognize any of them. The man took her arm and gently guided her through the crowd and onto the path. Then everyone followed. They went through a grove of scrub oaks and around clumps of chaparral. They were quiet, except for the sounds of their rustling dresses and footsteps on the gravelly trail. They walked awhile. Then Mabel saw the water, a large pond holding the entire nighttime sky, and when she looked where they were headed, she saw a fire by the water and four older men and a woman who were singing softly, their words like cottony dandelion seeds floating in the air and dropping on the pond. The man led her to the fire, and right there next to the water, just in front of the singers, he pointed to a bed of blankets on the ground. Mabel sat down and then stretched out on the blankets. The singing stopped.

The man took off his hat and carefully placed it at his feet. He straightened and faced the crowd of singers and others gathered in the firelight. Then the younger man who had been in the car came through the crowd carrying a thick willow pole at least twenty feet long, and he set it on the ground alongside Mabel. The old man started speaking. "We will sink this woman under the water tonight. I'll push her under this sacred water with this pole. We'll pray each night, and on the fourth night, before dawn, she'll float up. It's how we

Medicine Woman

do with young doctors." He began singing a song, and Mabel fell asleep.

"Don't worry," the spirit said, "he isn't going to put you under that water. I'm explaining it to him like I'm explaining it to you . . . You see, that is the sacred water place. It's for the doctors who train just on the earth and for old-time Roundhouse leaders. There is a place under that water where those kind of doctors go in and get all the things they are going to use here on the earth. But you're not that kind of doctor. You're not going to be a Roundhouse leader. You don't have a people with a Roundhouse. But you will have people, even though they are strangers to you now. You're a Dreamer, one who trains only by me, not by anyone on the earth. But people on the earth will help you. This man singing over you and listening to me will be the first. Then there will be a woman, a Dreamer like you. You'll see her many times before you meet her here on the earth . . .

"Listen to me now. You make a basket to spit out the sickness you suck with your mouth. Your throat has already been fixed, given. That extra tongue can catch the sickness and stop it. You catch it in your throat, then spit it out. There are many sicknesses. Some move fast, so you have to put them to sleep with certain songs I give you. The songs I give you will leave after you are finished with the patient. You won't remember. You won't even know what you are saying through me to the patient and the crowd. That's why you will have to have an interpreter who thoroughly understands your language and can tell the people what you are saying while you are under me. And there's more . . . You will have an elderberry clapper and a cocoon rattle for keeping the beat with your singing and for calling me to work. Do you understand?"

"How am I supposed to get a clapper and rattle?"

Medicine Woman

"Don't worry. It comes from me. Another thing . . . Your baskets, they will all come from me. You will be famous. People will want you to make baskets. They'll offer you lots of money. But you pray to me first. I'll show you what to make for each person. Each of your baskets has a purpose. Each has a rule. But a lot of people won't understand that. You must explain, show the people that the baskets are living, not just pretty things to look at. Some basket-makers just make baskets, but that's not you . . . You've been cut out different. Just like you're a different kind of doctor. Many people are doctored under me in different ways. You can't be a doctor like that person, and the next person can't doctor like you. They have to be all cut out different. But it's made by that same spirit, not two or three spirits. I am many. I am many places . . ."

Mabel listened for four days and four nights. She asked questions, sang songs over and over, learned things that only she could know, things the man singing over her couldn't hear the spirit explaining. When she awoke, she was on her feet singing. She was facing east. Pink light was in the sky.

She found she was surrounded by people. Not just those who had walked with her along the path four nights ago, but people she knew. Her family, her uncles, her mother, and grandmother. Cortina people. People from Rumsey and Sulphur Bank. A huge meal was spread out on picnic tables under willows by the pond. Acorn mush, pinole, all kinds of food for the new doctor. The old man stood before a table with food that Sarah and her family put up for him.

"I sent word to each of you," he said to the crowd gathered around. "I sent word for you to come this morning and witness this new doctor standing alongside me here . . . That's what I'm praying about now as I bless this food." He walked

counterclockwise around the table four times singing a song.
Mabel followed him. Later that day, after the people had finished eating, when only Sarah and a few others were still there, packing up leftover food in boxes and paper bags, the old man took Mabel aside and handed her a short, brightly polished split elderberry wood clapper and a small, plain pipe. "This pipe is part of your doctoring too," he said. "You know, the spirit told you about it, how you are to use it when you smoke angelica . . ."

Mabel nodded that she understood and thanked him. She saw that the elderberry clapper and the pipe looked just as they did in her Dream.

"I can't give you the cocoon rattle," the man told her. "That's for your other helper to do, that woman the spirit showed you the other night in the white dress. Remember her?"

"Yes," Mabel said, holding the clapper and pipe together in her right hand. "Yes, I saw her."

"Well, she's already Dreaming about it. She's seeing the grove of alders where the butterflies make their cocoons and she's seeing you . . ."

The man talked awhile and then sang a few songs for Mabel to hear and remember. He said they were songs from the earth and that she should have them since so much of the sickness that she would have to work with was made and used on the earth. "And you know about liquor and dope. You're going to have to doctor people who are drunk and doped up. So you got to see all kinds of people like that. Oh, the spirit told me about your journey in wild places. Don't worry, I know about liquor and dope too. Especially the liquor part," the man said. He started chuckling, then he turned and left. Mabel watched him go

up the trail and disappear through a thicket of low-growing manzanita.

"We can go now, too," Sarah said, walking up to Mabel.

It wasn't long after that, maybe a week or two, that Mabel had her first patient. It was one of her mother's husband's relatives, a Wintun man from the Rumsey Reservation. His family brought him to the little house behind the store-keeper's barn one evening. Daisy was with them. They settled in chairs around the front room, around the man who lay on the couch where Mabel had been sleeping only weeks before. They said the man had pneumonia, that he was going to die. Mabel stood alone in the back room. She was unsure of herself. She didn't know what to do. Her mother came in and urged her to come out. "You must," Daisy said. "I told them you could help him."

"I don't know what to do," Mabel answered.

"You must," Daisy insisted. "Use your clapper. Sing your songs. I'll interpret for you . . ."

Mabel hesitated.

"You must," Daisy continued. "You must. Don't just stand there."

Where else am I going to stand? Mabel thought to herself. Then, all at once, she got an answer. "You go stand over the patient."

So she went into the front room. She took her clapper with her. There was an empty chair facing the couch, and Mabel sat down in it. Daisy pulled up a chair on her left. "Oooooo," Mabel sighed, calling the spirit. Her throat started to move and out came her song, then another and another. By the third or fourth song, she was using her clapper, and now Daisy joined in, singing the songs alongside her. Mabel stood up and danced in place. Then she sat down

and began talking out loud, and Daisy repeated. ". . . He will live. He will be OK. He is to drink Mountain Balm tea. The sickness will be taken out now, but it could come back if he's not careful." Mabel moved her right hand back and forth over the man's chest, and the thick mass collected in the man's lungs broke up so that he could breathe easily. She massaged him for a long while, then sat back in her chair, exhausted. She dabbed her sweaty brow with a handkerchief Daisy handed her and closed the ceremony with her finishing songs.

The man's family put up a good dinner and they paid a large amount of cash. "You always pay your interpreters and singers," Daisy reminded Mabel later that night. "Yes," Mabel said, handing her mother a stack of one-dollar bills.

After the family and Daisy left, Mabel went to bed. Sarah had secured an old single bed from the store owner. She felt her granddaughter would be more comfortable on a bed. Sarah still slept on the wooden pallet on the floor. That night she didn't hear Mabel talk in her sleep. The spirit said to Mabel, "You did well. You have begun. Now you will go on, you will go up and up in what you can do. You will learn to use all the power I give you . . . Now rest."

Mabel's next patient was one of her uncles. He had suffered a stroke. He couldn't remember people's names. Again, Mabel sang and danced. She moved her right hand over her uncle's forehead. Later, when he sat up, he called for his wife, using her name.

Mabel regained her strength. She found she could work the way she used to, even after she had Dreamed half the night. She worked with Sarah washing and ironing clothes for the white people of Rumsey. The storekeeper and the sheriff's wife remembered her as a sickly child. "My, you

turned out handsome," they said, seeing Mabel as a grown woman. Mabel was dark with a high, wide face. She looked similar to many of the full-blood Indians of the area. She was short like them, too. But she was very trim, not at all heavy like her mother or her uncles' wives, and she always looked immaculate. She wore pressed dresses and nylon stockings. Her straight black hair was bobbed just so in the current fashion. When she came up from the creek bed, after washing and pounding buckets of wash in the hot sun, she didn't have a trace of muddy sand on her. While working, she wore an oversized apron that covered her completely, and when she finished the wash, or whatever she was doing, she took off the apron and looked as clean as when she had started.

She learned to drive. Uncle Anderson lent her his car so that she and Sarah could get from house to house quicker for their work. The car also made it easier to visit relatives. Once Mabel drove Sarah to Lolsel to see Belle. Mabel remembered Belle from the few times she went with Sarah on the wagon to Lolsel. But that had been ten years earlier, and Mabel was surprised to see how old Belle had become. She was small, shrunken in age, older-looking than Sarah. Belle was surprised too: the sickly little girl she remembered was a grown woman. "Oh, my," Belle exclaimed seeing Mabel. "Oh, my."

The three of them visited well into the night, long after the rancher's daughter brought them a meal. The white girl Belle had cooked for and cleaned up after was now taking care of Belle. "Aren't you lonely here?" Sarah asked at one point in the evening. "Come live with us in the valley."

"Yes, Aunt Belle," Mabel joined in.

Belle shook her head. "No," she said. "I was born here, I had my children here and lost them here, and I'll die here too." She paused and looked at Mabel. Then she turned to

Sarah. "Sister, you have children. They can live on down there in the valley."

"Naw, that's not living," Sarah scoffed. "My children aren't Lolsel people anymore. My sons and daughter speak Wintun now, even to me. And their children don't know a word of Lolsel. They don't even know about this place. They don't care."

"I don't know. I don't ever leave this place, but the white lady tells me all the Indians are like white people now. I speak good English and talk with her."

Sarah adjusted herself, where she was sitting on the floor opposite Belle. "It's true," she said. "Indians are like whites now. More and more, they're that way. Old-timers are passing away. No more dances here and there. Younger people are letting it go . . . Richard's Dream, oh, how it is coming true. Roads are going everywhere. Look at this new world. More and more white people. Like ghosts, you can't stop them. And no more Indians. Just you and me here . . . "

"And your beautiful granddaughter," Belle quickly added, causing Sarah to stop in the middle of her talk.

Mabel sat alongside the two women and listened as they chatted back and forth and told stories about the old days. In the early morning, she went out by herself. She passed the corrals, where the rancher's son-in-law was leading a milk cow into the barn, and then made her way along the top of the creek bed. She passed the graves there, went under the large oak tree, and came out on the open field. She walked toward the center of the field, and kept walking until she found herself before the large crater in the earth. The elderberry tree was gone, pulled up by the rancher who planted the field with clover and vetch for his cattle. But Mabel found where the entrance was, a six-foot-wide path leading down

into the crater, and she stood there and prayed. "Great-Uncle, I don't know you, but I respect you. And I remember. Ooooooooh!"

Sarah and Mabel left Belle shortly after breakfast. About a year later, Belle passed away and was buried in the little cemetery above the creek. The rancher insisted a tombstone be made with her name.

When Mabel and Sarah got back to Rumsey, they went right to work. The sheriff's wife, who was quite old now, wanted Mabel to wash windows. After the drive from Lolsel and the long day's work, Mabel wasn't surprised at how tired she was in the evening, after supper. She went to bed. Then something happened, someone was calling her, a voice she hadn't heard before, a man's voice. "It's me, I'm over here," he said.

She looked and saw an old white-haired man in the dark. Just his face, and he had a broad nose shaped just like Sarah's nose.

"Of course, I've got a nose like this," he said, seeing Mabel looking. "I'm your great-uncle Richard. Thanks for the prayer this morning."

Then Richard disappeared and another old man took his place. Again, Mabel could see only the man's face. He was white-haired also and had a wide down-turned mouth that seemed to move very little as he spoke.

"That was my son. We both saw you this morning. Thank you. I'm your grandfather's father, in case you haven't figured. I'm Old Taylor."

"Am I Dreaming?" Mabel asked.

"Yes, you're Dreaming. We're part of it, the Dream. We're ancestors."

"Well, what am I supposed to do?"

The old man laughed. "Nothing. I can't tell you what to do. That's your spirit's job. I just want to offer you a gift. Something to help you with your work on earth, something I know from my time on earth. It's a rattlesnake song. The rattlesnake is a good helper and friend. Here's the song, listen . . ."

Mabel hummed the song. She sang it in her Dream. But she never did sing it out loud when she was awake. Still, something unusual happened. About two days later, she and Sarah went to look for clover along the creek. They drove north and stopped at a place where the creek was wide and marshy, even in the summertime. When they got out of the car, they saw that the trail leading to the water was covered with snakes, rattlesnakes of all sizes stretched in the sun, and their sharp, pointy heads were lifted, looking up to the road.

"Don't worry," Mabel said. "I told you about my Dream."

Sarah took a step backward, reaching for the car door handle behind her.

"Don't worry," a voice said to Mabel. "We're your helpers."

But Mabel turned and got into the car with Sarah.

And that was just the first of it.

Mabel found snakes everywhere she went. On the white people's porches, in their gardens. In the fruit orchards, in all the places she picked herbs, and sedge and willow for her baskets. On hot days they came into the house and rested in the cool bathtub. They curled up in her shoes. She found them in her purse and coat pockets. "Grandfather," she prayed. "I believe the snakes are helpers. Thank you. But I can't live this way. These are modern times. The white people will call the animal control. They'll kill the snakes. You must take back that song."

Medicine Woman

"OK," he said, "but you must remember us. I'll take that song out of your body, but I want you to have a couple others. One is for your travels on the road, wherever you go. The other is to calm the earth when you're cutting or digging things for your baskets. Now listen . . ."

Mabel learned the songs and sang them. She sang them in the car as she drove here and there with Sarah. She sang them every time she dug sedge or cut redbud bark and willows. Sarah recognized the songs. She said she had heard her father sing them when she was a young girl, only he had sung the songs when he was going to walk to Clear Lake or pick Mountain Balm and soap plant in the hills.

"Different time," Mabel said.

"Same songs," Sarah rejoined.

Still, Mabel kept seeing snakes. Not as often, and usually when she was digging sedge. They'd poke their heads between the reeds, looking at her. "They still hear that song in your body," the spirit told her. "You have a scar where that song lived and that scar is singing yet. But don't worry. They hear your ancestors. They like you. Just go on with your work, keep digging. You have baskets to make."

Mabel wove three hours a day, even after full days of picking fruit in the orchards or washing and ironing clothes. She wove baskets for her patients. She wove baskets for doctoring. She began weaving feather baskets, creating colorful designs with feathers from the meadowlark's yellow breast and the mallard drake's metallic green neck. People took note of her work. They brought her skins of birds—robins, quail, meadowlarks, mallards—which she dried on newspapers and plucked feather after feather from for her baskets.

"They weave baskets like that on the lake, where her father comes from," someone said once, while examining Mabel's work.

But even in Lake County, and west of there, where women were known to weave feather baskets, none of the baskets looked like Mabel's. Her miniature baskets, which she gave to people as gifts of protection and healing, were the smallest things anyone had seen. Sarah said they were even smaller than Mollie's miniatures. "Mama never made them that small," Sarah attested, as she studied the intricate minuscule designs with the storekeeper's reading glass.

Soon the white people took notice. The sheriff's wife. The woman on the hill. Some of the new people moving into the area. Word spread. They begged to see Mabel's work. Specialists came from Sacramento. Art collectors offered her high prices. Long gone were the days a collector could toss a few coins into an Indian woman's lap and take her baskets. But Mabel promised nothing to anyone. She had them sign their names on a ledger, and at night, before she went to bed, she ran her fingers back and forth over the names. People waited for their baskets, sometimes for years. Some orders were filled. Some were not.

In the summer of 1929, when Mabel was twenty-two years old, a basket specialist arranged for her to exhibit her work at the California State Fair in Sacramento. Mabel agreed and took two weeks off from her work with Sarah. At the fair, a white woman cut her a beaded buckskin dress with fringe and gave her a pair of moccasins and a dyed turkey feather to put in a beaded headband. She tugged and pulled on Mabel until she was satisfied with the clothes.

"Do I look like a Indian yet?" Mabel asked.

"Well, almost," the woman answered, catching none of Mabel's humor. "Yes, I think you do."

"Well, I'm sorry to say," Mabel said, "but the dress is too short. Indians don't wear the buckskin dresses so short, not that I know anyway."

Medicine Woman

The woman looked down at the buckskin barely covering Mabel's knees. "Oh, dear," she said. "I didn't think of that."

"Yeah," Mabel said, hardly able to contain her laughter, "I ain't worn no dress this short since the carnival."

"Well," the woman said, straightening, "you'll be sitting behind a booth most of the time anyway. And when we take your picture, you can be standing so people don't see your legs. Darn it, all that work on the moccasins."

Mabel sat at her booth in the display hall from ten in the morning until ten at night. Daisy sat with her most days and watched the booth when Mabel took a break. More orders. More interested people. When Mabel went back to Rumsey she had two ledgers filled with names and a framed photograph of herself standing behind her display of basketry in a buckskin dress. On the display table sat a placard that read "This Pomo Indian maiden CATANUM is considered the foremost basketweaver of all the California Indian tribes."

While Mabel received attention from the white people for her basketry, her life at home with Sarah changed little. She worked washing and ironing. She worked in the orchards. She wove baskets. And, when called upon, she doctored the sick. Many people liked and respected her. Others were jealous and suspicious, telling stories among themselves about Lolsel and white snake poison. Then, that fall in 1929, she met a man named Jake. He was from Sulphur Bank, in Lake County, and he was working in the grape vineyards north of Rumsey.

It was nothing special at first. He was a man she and Sarah passed on their way to the outhouses after work each night. Among large crowds of Indians, Mabel was always escorted now in case some poison person might want to harm her. Poisoners looked for opportunities to kill those who could

interrupt their work. Mabel saw him squatting by the fire in front of his tent. Night after night he was there watching as she passed by with her grandmother. One night, shortly before the grape harvest was over, he smiled. She paid no attention; she didn't think much about men. But the next day she found him working opposite her, on the other side of the grapevines.

He was handsome; a wide, white smile; black hair stylishly cut. He kept looking through the vines at her, parting leaves so he could catch her eye. She didn't look back at him, but neither did she alert Sarah and Daisy, who were working a few steps from her. She didn't think he was a poisoner. Not since her days in the carnival and in San Francisco had a man looked at her the way he was looking, not that she had noticed anyway. And she sensed something about herself, something curious, something light-feeling. And she felt that if she met the young man's eyes, he would know this about her completely. Which is why she didn't look back at him, and why she didn't understand the confidence he felt that same night when he put three sacks of flour, a dozen blankets, and an impressive row of clamshell-disc beads outside Sarah's tent, and a wad of cash in Daisy's hand. These were new days. Even in the last few years things had changed. Young Indian women knew they could choose a man, that they didn't have to obey their parents when it came to marriage. The white man's law was on their side.

"I accepted the money," Daisy told Mabel later that night.

Mabel didn't answer her. She went back to the tent she shared with Sarah. Sarah left the flour and blankets outside. "I only took in the beads because someone could easily walk off with them," she assured Mabel.

Medicine Woman

Mabel sat down on her sleeping bag spread on the ground. She told Sarah who the man was.

"Have you talked about marriage with him?" Sarah asked, imagining Mabel sneaking a life separate from her or Daisy during the last few weeks.

"I don't even know him," Mabel said.

Sarah told Mabel she knew the man's family, that they were good people from Sulphur Bank, where Sarah and other people danced after Richard Taylor passed on and the Lolsel Roundhouse was closed. "But you must get to know him, talk to him," Sarah said.

Which is what happened, at least the talking part.

Jake was waiting outside Sarah's tent the next morning. Mabel passed him and made her way to the outhouses. He followed, but she paid no attention. On the way back, before they reached the rows of tents, he said in English, "The mother accepted the deal."

Mabel spun around and faced him. She was livid.

"Yes," he said, before she could say anything. "Now, if I can only figure out a way to please the grandma. I was wondering, do you think maybe you could help me?" He dropped his head, affecting the manner of a lost four-year-old.

It wasn't what Mabel expected. He caught her off guard, sidestepped her anger. Without lifting his head, he looked up at her. "You see, the grapes is over in just a couple days. I'm going to work the hops way over Ukiah . . ."

He talked on a while longer about his plans, and even before he lifted his face, looking at her directly and waiting for an answer, she saw herself going with him, her cardboard suitcase packed full and bouncing around as the two of them made off over the hills and down into Ukiah.

Medicine Woman

Only it turned out that it wasn't just the two of them. It was half a dozen of his friends and their girlfriends and wives stuffed in a car that overheated on the way up the hills and blew two tires on the way down. When they pulled into the hop fields outside Ukiah, they didn't register at the camp. They went swimming in the Russian River and found themselves sleeping in the sand without blankets or bedrolls. Except for Mabel, every one of them was drunk.

Mabel had never worked or spent time in the Ukiah Valley. She didn't know any of the people. To the east she saw the hills leading to Clear Lake, from where she had come; to the west the great chain of hills lining the ocean. Right away, a couple of women introduced themselves.

"You're Mabel Boone, aren't you?" they asked.

Mabel wasn't accustomed to people calling her anything but Mabel. "Yeah," she answered.

"Well, we're your father's cousins. Lots of Potter Valley people here."

"Oh," Mabel said. "Oh."

But she would not have time to visit them. Jake worked half a day in the hot sun and then decided to leave. "This is no life for my new wife," he said. "Let's get out of this place." He caught a ride with an old man to the lake, and before it was dark, Mabel found herself looking over the empty one-room shack she would call home for the next two years. "I just want you to sit and make baskets," Jake told her.

"I have to have a chair first," Mabel said.

It was on what the Sulphur Bank people called the priest's land. It was a strip of land, about thirty acres on Lower Lake, which was south of the Sulphur Bank homeland called Elem. Twenty years before, a Catholic priest donated the land to the homeless Indians of the area. People from different tribes

around the lake took Holy Communion from the priest and settled on the place. Now the priest was gone and most of the fifty or so residents were from Elem, or Sulphur Bank. Jake's shack had been built by his father, who had passed on some years earlier.

Mabel fixed the place up. With earnings from her basketry, she purchased a table and four chairs across the lake in Middletown. An old man she had doctored repaired the wood-burning stove and rusted stovepipe. His sons patched the roof, built a bed frame, and plowed the hard earth behind the house. They spent days picking stones out of the up-turned soil. Mabel sewed curtains and planted a garden. She traded neighbors pies and stews for seeds.

She had time on her hands. There was very little work around the lake. Very few orchards and farms. She didn't know any white people who needed help with housework and washing clothes. In fact, the lake people seemed to mingle less with whites than the valley people did. So she spent more and more time weaving. The basket specialists tracked her down, and the orders kept coming, the ledgers filling with new names. They asked if she would weave twined baskets—all of her baskets were coiled. She said that she had made some twined baskets when she was younger, but that now she made only coiled baskets. She gave them names of Pomo weavers who twined. She followed the spirit. Day after day she sat at her table piled with sedge roots and rolls of redbud bark and peeled willow rods. Sedge roots soaked in a small bowl of water so they would be pliable when she picked them up and wove them around and around the willow rod, opening a space for each new stitch with her steel awl. She wove in redbud for the colored design, and feathers too, seeing a pattern form that was clear in her mind as she coiled around and around.

Medicine Woman

But Mabel also used the time she had to visit the friends she made. The Sulphur Bank people were friendly to her, which was not surprising given the amity and goodwill between them and the people of Lolsel. If there had been work around the lake, Sarah would have moved to Sulphur Bank rather than to the valley. The Sulphur Bank women showed Mabel the best places to dig sedge. Some of the finest redbud anywhere grew in Sulphur Bank territory. In exchange for the women's generosity, Mabel put up great dinners, and gave each of the women a miniature basket for her health and protection. She explained her basketweaving rules—no drinking or menstruating when you weave—and provided they followed the rules, she showed them how to trim sedge roots just so and how to use willows picked at certain times of the year so that their baskets would be watertight. Aside from the brief lectures she had given each day at the State Fair in Sacramento about the materials she used in her basketry, this was her first experience teaching. She sat with the women, checking their work and making suggestions. "I remember my grandmother used to say the same thing," one of the women said after Mabel showed her how to gently bend a willow rod.

The women, in turn, taught Mabel a lot about cooking. Mabel learned to make chili and stews that Sarah never cooked. She learned how to bake mud hens taken from the lake, though she never cared for the greasy taste of the little fat gray birds. And the women taught Mabel the Sulphur Bank language so that she was rapidly fluent in a third Indian language. Lolsel Cache Creek Pomo, Southwestern Wintun, and now Sulphur Bank Pomo. When the women went across the lake for groceries or took trips to visit friends or relatives in other places, they often left their children with Mabel.

Medicine Woman

Mabel loved children. She loved watching their eyes dart back and forth at people and things in a world that was always fresh and new. She loved seeing them take their first step. She spent a lot of time with her friends' children. In the evenings, without her friends or their children, she found that she was lonely.

Jake wasn't around much. He followed his friends to the valley or over to Healdsburg and Santa Rosa. He always had some job. He described in detail arrangements he and his friends had made with a rancher or someone, and then when he returned empty-handed and smelling of wine, he couldn't remember what he had told Mabel. He got angry when she asked what had happened. "I wouldn't have to go to work like a damned mule if you would weave more baskets," he said, lashing out at her. "Charge more money, and don't be giving them to people around here. Let them make their own." He questioned her doctoring, suggesting that she had doctored his cousin from Middletown just so she could rub the man's chest. He didn't like her visiting with people. He wanted her to work constantly. He watched her every move, that is, whenever he was home. He claimed spies watched her for him while he was away.

Once, when Jake had been gone for a week, Mabel traveled up to Elem for a dance with the Sulphur Bank people. She loved the dances. The songs and costumes and the people dancing together reminded her of the time she danced under her grandmother's dress in Cortina. Only now she didn't have to hide. She was a respected woman and a fine dancer. Jake had come home and found she was gone. He figured she went to Elem for the Sulphur Bank ceremonies. When he found her, she was dancing inside the Roundhouse in a circle of women. He grabbed her arm and pulled her

outside. "I told you," he said, shaking her, "I told you to stay home."

One day not too long after that, Mabel went to the rodeo in Middletown. She disobeyed Jake again, but afterward it wouldn't matter anymore. She was standing outside a make-shift rodeo corral with her friends watching a calf-roping contest, when a tired-looking older Indian woman ap-proached and asked if she was Mabel Boone.

"Yes," Mabel answered.

"Is your father Yanta Boone?" the woman asked. She spoke very broken English.

"Yeah, but I don't know him. I never met him."

"Do you want to meet him?"

"Well," Mabel said, hesitating.

The woman pointed to her right with her chin. "He's there. He's asking if you want to talk to him."

Mabel looked and saw a small, thin silver-haired man leaning against the corral and looking in her direction. She could tell, even before she went close, that he was drunk. Something about the angle of his body braced against the fence. He wore denim jeans and a World War I veteran's jacket that was dirty and badly stained. As Mabel ap-proached, he began sobbing, shaking uncontrollably. "My girl, my girl, forgive me," he cried. "I had to go into the war. I had to leave you for the war . . . Nothing's been the same since. I went to war . . ."

Mabel didn't think to remind him that she was ten years old when the war broke out. She didn't really think to tell him anything. She saw maybe a faint resemblance in his eyes and brow. But more than anything, he struck her as a com-plete stranger. She let him babble on about his miserable luck in life. When she turned away, what caught her eye was the

woman with him. The haggard woman sat on the bottom step of the bleachers now, staring through the fence to the arena. She didn't move or look up. She had no interest in Mabel or what went on between Mabel and Yanta. Yet she was there, as she had probably been for longer than she could remember, waiting for what Yanta told her to do or say next.

"What happened?" Mabel's friends asked. "Is that really your father? Whew, you can smell the whiskey from here."

"Yeah, it's him," Mabel answered.

"What are you going to do?"

"I'm moving," Mabel said. "Which one of you can get me a ride to the valley tonight?"

So Mabel went back to Sarah. She packed her clothes and basket materials and left the table and chairs and everything else for Jake. But when she reached the valley, she found that the little house behind the storekeeper's barn was locked up. Her key didn't fit the lock. She thought Sarah had died. Luckily, the storekeeper's daughter found her standing outside the place with her cardboard suitcase and informed her that the storekeeper had had a stroke and was living in Sacramento with relatives. "We're selling the place," the blond woman announced. "Your grandmother moved to the reservation."

The woman gave Mabel a ride up the road and dropped her off at the dirt path leading to the row of reservation houses. Sarah was living with Daisy and her husband and daughter, and there was enough room for Mabel too. Mabel quickly settled in and resumed her work washing clothes and cleaning houses with Sarah. She worried for a long time that Jake would come after her; certainly someone on the priest's land told him where she went. Harry, Daisy's husband, kept a

loaded pistol in a kitchen cupboard. But Jake never showed
his face, not even in the orchards during the harvest season,
and soon Mabel didn't give him a second thought.

"How come you didn't have babies?" Sarah asked one day
while she and Mabel pounded clothes at the creek.

"I don't know," Mabel answered.

"Don't matter," Sarah said. "I got grandchildren and great-
grandchildren enough now."

"I don't think I can have children," Mabel said wistfully.

"What?" Sarah asked.

"I think I've been fixed so I can't have children. The spirit
said I'm not cut out for having kids. Said that, after I miscar-
ried once up at the lake. But then said I would have a child
after I couldn't have kids no more. I can't figure it out."

"Don't think about it."

"No, I do sometimes. Besides, people who don't like me
are going to start mentioning it to people. 'See, she's poison.
She doesn't have children. Nothing to lose when she kills
people.' "

"Well," Sarah said, stuffing dried wash into a bucket. "It's
not only poisoners . . . It's good for good doctors too. Poi-
soners won't be able to harm your kids. You know they try
that with good doctors' children."

Mabel stood up and started for the car with a bucket of
dried wash.

"Don't get sad," Sarah called after her. "The spirit said you
were going to have a child."

But for those first few months back in the valley Mabel
was often sad. Not that she missed Jake. She didn't. Or that
she missed her friends on the lake, which she did. Or that she
was childless and unmarried. It occurred to her that, with or
without children, married or not, she always had been and

always would be different from the people around her. She knew enough about married life and day-to-day living to know its joys and pains, and she knew enough from the spirit to know that that day-to-day life would never be hers completely. She had no choice in the matter.

The spirit directed her to weave more baskets. "You'll be so famous, you'll teach in the colleges one day," the spirit said. "How am I going to teach in the colleges when I never even went to college?" Mabel asked. "You'll know from me. You'll do what you know from me." More and more patients came for her help. The Great Depression was on, and even those who had long given up faith in Indian doctors found themselves desperate and at her door.

Once, while she was singing over a woman from Colusa, she found herself unable to extract the pain in the woman's chest. Her hand had located the pain, what the spirit described as a tiny spotted fish, but she was unable to pull it up, out of the woman. "Now you have to use your mouth," the spirit said as Mabel sang. "How am I going to use my mouth?" she asked. The spirit said: "Your throat has been fixed for many years. Now it's ready to use. And that basket you completed a while back, that spitting-out-sickness-basket at your side, it's ready too. It's hungry. You must feed it with your spit. Now, you are ready. The song has put that little fish to sleep. Take it out with your mouth . . ." And Mabel took the fish into her throat and coughed it out into the basket. The Colusa woman was healed that way.

"She's a sucking doctor, too," Daisy exclaimed, knowing that sucking doctors were always regarded as the most powerful and valuable doctors. "I didn't think there would be any more sucking doctors." Mabel knew better. She knew she would be a sucking doctor, and she knew she would be the last.

Medicine Woman

During her stay at Daisy's place on the Rumsey Wintun Reservation, Mabel got to know her sister, Frances, who was about twelve. Frances was a quiet girl who resembled her father, Harry Lorenzo. There was no doubt Frances was the Rumsey Wintun chief's daughter. She was Wintun in every way: language, manners, and gestures. Sarah and Daisy encouraged her to weave baskets, and Mabel spent time showing her how to dig and prepare sedge roots and where to pick the best willows and redbud. She demonstrated a real talent for weaving and, before long, was creating beautiful Wintun baskets.

In the three or four years that followed, Mabel found herself assuming more and more of Sarah's work. Sarah couldn't work as fast or as long anymore. Still, she went with Mabel day after day to the white people's homes to clean and wash clothes. And she still worked in the orchards and fields during harvest season. Not much changed for Mabel during these years: work, weaving, doctoring. Then she met Charles McKay. Charlie. A handsome Wintun man from near Redding. She had dated a few other men, but Charlie McKay was the only one to get a yes from Mabel, even if it was a very tentative yes at that.

"I ain't the marrying kind," Mabel told him one evening as they stood talking on the path outside Daisy's place. "I'm too busy running around with my doctoring."

"Couldn't we just try it?" he asked, holding his new hat in his hand. He was clean, fresh-looking, shaved, his dark hair combed back just so and smelling of cologne.

Mabel liked him. He was kind, extremely gentle. She had seen as much in the way he saddled a horse and the way he retrieved a cat run up a tree by a pack of dogs. He was courteous to her family. When he called on her, he always brought them something: fresh fish for Daisy and Sarah; a hairbrush,

once even a pair of patent leather shoes, for Frances. And he always asked Mabel if she was busy, if something had come up, even if they had set a date that day. He understood some-one might be sick and need her. Still, Mabel was hesitant; she remembered too well how confined she had felt living with a man.

"I ain't gonna cook for you, nothing," she said.

"That's OK," Charlie responded.

"I'm not the wife type. I come and go whenever the people call me. And you can't be following me around."

"I won't, I promise."

"Another thing, you don't be looking to me for money."

"No, I won't. I got a good job."

Mabel saw the setting sun lighting his face. She saw that if nothing else, good job or not, Charlie at least believed what he was saying to her.

"C'mon," he said. "Let's try it . . . Just three weeks. If I break any of my promises, you go. If not, if you still care for me, we'll go to the courthouse and get married on paper."

"Three weeks," Mabel said.

And so Mabel went with Charlie to Lake County, in the hills above Clear Lake, where Charlie worked for a rancher. It wasn't too far from Nice, where Mabel was born. They set up house in a small cottage on the ranch, and each morning Charlie went out on a horse to look after the cattle and check fences. By sundown he was in the kitchen, bathed and in clean clothes, stirring a good stew or a pot of chili for dinner. He kept his promises, except one. He followed Mabel.

Daisy arrived one evening with a Maidu woman from somewhere near Sacramento. The woman asked Mabel to doctor her niece. Charlie heard where Mabel and Daisy planned to camp along the Sacramento River, and when

Mabel didn't come home after three nights, Charlie went to find her.

It was late, about two in the morning, when Daisy bolted upright in her sleeping bag. She nudged Mabel, who was sleeping between her and a cousin from Cortina. "Someone's in the bushes," Daisy whispered.

Just as Mabel looked, she saw Charlie coming through the thicket. "What do you want?" she said. "I told you not to follow me."

Charlie looked at Mabel camped safely between the two women. Without a word, he turned and left.

"I know I'm fired," he said the next morning when Mabel got home. He was sitting at the small kitchen table, looking at the rolls of redbud near the salt and pepper shakers. It was long past the time he should have been to work.

"Why did you come after me?" Mabel asked, standing by the sink, waiting for the water to boil on the stove.

"I didn't know what happened."

"Were you jealous, thinking things?"

"No," he answered, looking up at her. "I thought something happened to you." He paused and looked back at the redbud. "Well, maybe a little jealous. But mostly I was worried. I didn't know what happened."

"Well, you don't worry about what happened. Even if I'm gone somewhere, you'll find out. Don't worry about it. What you gonna do, anyway?" Mabel lifted the boiling kettle of water off the stove and poured herself a cup of coffee. She set the strainer with the coffee grounds in the sink and stirred the cup of hot coffee. "Well, now you know me and I know you. You won't be following me again." She saw Charlie sigh in sorrow. "So when you get a day off, let me know, and we can go to the courthouse."

Medicine Woman

Charlie looked up in disbelief.

"Now, don't sit there like that. Get on that horse out there or you really will be fired."

So they got married and Mabel became Mabel McKay, the name people would know her by. Mabel McKay, basket-maker, medicine woman.

Charlie was talkative, outgoing. People liked him, Indian and white. He always wanted to have his own ranch. A rancher near Potter Valley, west of where he and Mabel were living, gave him a start. Knowing that Charlie was a good worker, the rancher offered him a dozen whiteface cows and a couple of horses if Charlie would work as a foreman on his ranch and oversee a large herd of cattle. Charlie jumped at the opportunity, and he and Mabel moved to a clean one-bedroom home on the ranch. Charlie's small herd grew, and, as it turned out, Mabel was the one who looked after the McKay cattle. Charlie worked seven days a week, sunup to sundown, with the rancher. So Mabel learned to ride horse-back and herd the whiteface cows and their calves off the hills and into the corrals next to the hay barn; she was as good at it as Charlie or anyone else. And it was Mabel's savings that paid for hay each winter. Charlie complained that Mabel fed the animals too much hay. "It's just gonna take them that much longer to fatten up in the spring," Mabel retorted. "Who's gonna buy skinny beef cattle? Makes no sense. We'll never earn enough money to buy our own place that way."

In the late spring, after calving season, when Mabel had some free time, she enjoyed visiting people she knew around the lake. She visited friends at Sulphur Bank, where Jake

never showed his face, and she got to know some of her father's relatives from Potter Valley. People called on her to doctor, and once after she had finished doctoring a cousin's husband's mother in Middletown, she heard talk of a powerful medicine woman doctoring up the road on the same reservation. "That's at my husband's sister-in-law's place," Mabel's cousin said. The cousin's father, who was related to Sarah, had married a Lake Miwok woman in Middletown. His daughter was raised among her mother's people, but she had managed to learn enough Lolsel Pomo so that she could converse with Mabel. "Let's go see her," the cousin said.

Mabel and her cousin arrived in the middle of the ceremony. A large crowd was gathered in the small front room of the reservation house. Mabel couldn't see much, except for the broad backs of the doctor's three women singers, who were seated behind the doctor. But the doctoring songs and the beating of elderberry clappers were loud and clear. A strange feeling came over Mabel. Then, all at once, the woman doctor stood up, from where she had been kneeling over the patient, and faced the crowd. She seemed to appear, suddenly take form in the space before Mabel's eyes. She was a tall, forceful woman, heavyset, with light skin. She was saying something to her audience, but Mabel didn't hear a word of it, for her throat was moving so fast and hard she thought the whole room could hear. "That's the one you're going to work with," the spirit said. "That's the woman in your Dream."

Mabel looked again at the tall woman. She had short hair, and her ceremonial dress was dark blue, not white as Mabel had known it to be in the Dream. "Don't worry about the details," the spirit told her. "Just learn her name so you'll know who to call on when your time with her comes." Mabel

did not introduce herself that night; she left with her cousin just after the ceremony was over. But she got the woman's name. Essie Parrish.

She thought a lot about the doctor woman. About how she looked and about her songs. But Mabel couldn't remember much in the days ahead. Just as the woman seemed to have appeared before the crowd that night, so she seemed to have disappeared. Essie Parrish. The name Mabel knew, and the Dream.

Sometime after World War II, the rancher sold his property. Charlie and Mabel were strapped. No home or land and a herd of cattle to pasture and feed. Charlie and Mabel now found themselves moving from place to place in and around Lake County: a spot above Nice where the ground was rocky and barren, the small ranch on the south side of the lake where their cattle kept jumping the fences. On and on they went, trying to hold on to the herd. In the end, they had only five cows left. They kept them in a pasture ten miles from where Charlie was working on an apple ranch, and Mabel had to drive back and forth each day to look after them.

That was around 1950. And it was then that Mabel got the call that Sarah had passed away. She was ninety-something, and she had worked to the end. Same routine, crying first thing in the morning, then straightening herself and on with the day's work, early to bed. There was a small gathering at the old Wintun cemetery across the creek in Rumsey. Charlie stood by Mabel. On the way back to Lake County, Charlie asked why they didn't bury Sarah at Lolsel.

"How could we?" Mabel asked. "It's private land. I don't know who owns it now. That rancher I knew, he's long gone." Mabel paused. "Besides, I remember Grandma there in Rumsey."

They were quiet a long time.

"Mabel," Charlie said all of a sudden, "I broke my promises to you. It's your money been keeping the stock going all these years. And the stock's my idea. It's made a hard life for both of us."

Mabel listened, watching the road in front of her.

"I'm gonna sell those five cows."

"But you like the cows," Mabel protested.

"And something else," Charlie said. "I know you would like a child. So would I. Your sister's pregnant, and she's already got many kids. Maybe she'll let us raise the baby."

"What are you talking about?"

"Adopting."

"I don't know," Mabel said.

"We could try. Have ourselves a family after all."

"I don't know."

But the idea worked. Mabel and Charlie found themselves with a son. Marshall. Marshall McKay. Charlie sold the five cows. The gentleness and care he once gave his animals he now lavished on his son. He changed and washed diapers, heated milk, held the boy all night if Mabel was away. And Mabel couldn't remember being happier. She felt a stability in her home, peace. She watched Marshall's eyes dart here and there. She watched him grow. He looked a lot like his natural mother, Frances, but by the time he was walking and talking, there was no doubt that he had picked up Charlie's gentle outgoing manner.

When Marshall was about four, the family moved to Ukiah, where Charlie got a job on a large pear and apple ranch. Through Indians he knew, he got a home on a local Indian reservation, a Pomo reservation. As always, Charlie worked long hours. Mabel found herself at home with

strangers living on each side of her. She hadn't lived on a reservation for years. She made a few friends, but many of these Indian people thought her suspect. Word traveled that she had power. But what kind of power? Poison? Wasn't she from Lolsel, that notorious place east of Clear Lake? They didn't know her.

One day while she was sitting on her front porch, she saw a woman staring at her from the side of a building across the way. The woman slipped into the shadows and disappeared behind a door. Still, Mabel got a good look at her. She was about sixty years old, shapely, but it was the woman's hair that caught Mabel's attention. I've seen her before, Mabel thought. That hair, wavy and parted on the side. Gray, but still the same hair. Yes, the same woman who sat on the wagon that night, the woman who was with the man who flew up in front of the moon.

One of Mabel's few friends told her about the woman. "She ran a house. You know what kind of house," the friend told Mabel. "She sold girls. Then that hopping-up-and-down medicine man you're talking about, he came and sang her right out of that house. That's what they say, anyway."

Mabel listened. In the days and months ahead, she often found the woman looking at her, from behind buildings, alongside thickets of brush. "That woman knows how to use the poison ground on a red rock in that cave," the spirit told Mabel. "The old lady that grinds the poison in that cave is this woman's spirit helper. Now come with me to the cave and watch how the evil spirit makes that poison."

Not long after that, Mabel's friend—the one who had told her the story about the woman—fell sick. Mabel doctored her and took a heap of red powder, like dried ground blood, from her body. "That woman poisoned you," Mabel said.

Medicine Woman

That was the only patient Mabel had had for months.
Not many people in the area trusted her, and she was too far away from the lake and the valley for those who knew her to find her easily. She began to enjoy not having to get up and go here and there. Her home was hers; no crowds of people gathered around as she prayed for the sick stretched out on her couch. But then she got sick. "You're bad off. You're not using me enough," the spirit said. "Now you need help."

"Find Essie Parrish," Mabel told Charlie.

Luckily, Charlie and Mabel's friend found Essie nearby, not too far away. She was staying with her sister Isabel in Alexander Valley, less than an hour south of Ukiah. They went there and Essie prayed.

"You're a good doctor woman," Essie told her. "You could be anything, Roundhouse leader, whatever you want. But you picked just doctor. You don't have a people. You will be the last of your people. But you will have a people. You know who I am, and I know who you are. You'll be part of me, my people. My children will call you Aunt; my uncles and aunts, they're going to call you Niece. You'll work with me and you'll be busy doctoring again."

She gave Mabel directions to the Kashaya Pomo Reservation above Stewart's Point, on the coast, and told her when to come. "One more thing," Essie said, "You must make a basket for me, for my doctoring."

So on the day Essie specified, Mabel arrived with Charlie and Marshall. They found the clapboard reservation house, and Essie was standing there on the porch with her husband, a sturdy handsome Indian man in his mid-fifties. Mabel discovered Essie had many children and grandchildren. Essie introduced her husband, Sidney, chief of the Kashaya Pomo. Then she said to Charlie, "Now sit and visit with my hus-

band. Let the boy play. Mabel and I are going down to the Roundhouse."

It was a large Roundhouse, fully above ground in the modern way. Yet Mabel sensed something old, timeless about the place. Essie's brother-in-law built the two women a fire and left them to do their business. They prayed and sang songs. Essie talked for a long time about her Roundhouse rules and the responsibilities Mabel would have to her and to the place. Afterward, they exchanged gifts. Mabel presented Essie with a finely made small basket that could hold water. Essie gave Mabel a bone whistle and a cocoon rattle made from monarch butterflies' cocoons and filled with beads. "You're gonna help with the earth poisons, Indian poisons, and liquor and dope which is hurting my people. You're good with that . . ." Essie turned and went behind the center-pole. When Essie returned, she was carrying her elaborately decorated medicine poles, one in each hand. Mabel saw the beautiful stars and crescent moons. Each pole was topped with clusters of cocoons. "One is yours," Essie said, handing Mabel one of the tall canes. "For when we work together in this Roundhouse. Because now we're sisters." Essie chuckled a moment. "We've been talking English to one another because we don't know each other's language. But we will know each other in spiritual things, our doctoring and ceremonies, because it's the same spirit. We're sisters by that spirit."

Essie paused. Mabel held the medicine pole in one hand, the cocoon rattle and bone whistle in another. Essie held her pole and the sacred basket.

". . . There's one more thing I should tell you," Essie said. "Some of my people will be jealous of you, of what you have there. They're going to say, 'Why her? Why this stranger

woman who's not from our tribe?' even though I stood here before this centerpole preaching to them about you for many years. I told them, 'Yes, I wanted someone from here.' But I looked, I searched my people, but *you* were the one picked by the spirit. Many of them don't understand that. They doubt the spirit. One day they will leave me. I'll stand here alone with only you and my children."

Mabel had a hard time believing what Essie said about standing alone, especially that night when the Roundhouse filled with Kashaya people for a dance. Mabel had never seen so many people in a Roundhouse, not since she was a child in Cortina. And nowhere these days, in the mid-1950s, was there a local tribe so involved with traditional activities, with the Dream dances. Essie had many men dancers. Women dancers surrounded the men. Entire families crowded against the walls watching. There were beautiful songs, half a dozen singers, including a rock holder who kept beat. Beautiful costumes, elaborate and expertly made orange and gray flicker feather headdresses and feathered skirts for the men. The women in their brightly colored, well-kept long ceremonial dresses. And they all listened when Essie spoke in front of the centerpole.

"Ooooooo," she called, closing a song and getting her people's attention. "Ooooooo . . . Ooooooo . . . Ooooooo. Now it's here," she said. "Prophecy is here. This woman standing beside me, she's the one I've been telling you about. She will be my helper on earth. She's my sister. So she's your relative, your aunt, your sister . . ."

They listened attentively. Nothing sounded but the cracking and popping of the fire in front of Essie. How could it be they doubt? Mabel wondered. And she kept wondering, at ceremony after ceremony with Essie. The Roundhouse filled

all the time, for every dance. The Kashaya people witnessed Mabel and Essie dancing with the medicine poles; they saw Mabel stand with Essie in white doctoring dresses. "Now this is the Dream," Essie told the crowd. "How we saw each other in the Dream."

After one of the dances, something unusual happened. Mabel had set her whistle down on a picnic table outside the Roundhouse. She had gone for a cup of coffee, and when she returned, the whistle was gone. She looked everywhere around and under the table, and retraced her steps to where she had walked for the coffee. She checked her pockets. "What's the matter?" Essie asked, seeing Mabel agitated. "My whistle, it's gone," Mabel said. Essie looked over the crowd. "I know where it is," she said and immediately started off, up the road from the Roundhouse. Her daughter, Violet, heard what had happened and followed her mother. "I'm here in case she gives you trouble," Violet said, as she and Essie climbed the steps of a relative's front porch. But there was no trouble. Essie knocked. The woman answered the door. She knew why Essie was there. She turned, without a word, and came back and handed Essie the whistle out the screen door.

"It was one of my relatives," Essie said, handing the whistle to Mabel at the picnic tables. The relative doubts, Mabel thought to herself.

Mabel and Essie quickly became best friends, sisters. They talked about everything with one another. Their lives growing up with their grandmothers. Their husbands and children. Essie told about how Albert, a doctor from the valley where Mabel grew up, helped her. "He gave me a song," Essie said. Mabel laughed and told about the time Albert frightened her in the vineyards. "He got us mixed up," Mabel

said. "He thought I was you. Albert's friend ended up help- ing me. I guess they got their wires crossed."

Mabel enjoyed the peace and beauty of the Kashaya Res- ervation. People were generally friendly with one another. They shared food, took care of each other's children. Mabel was impressed with the number of Kashaya who spoke the native language. On most local reservations and rancherias very few people spoke their Indian languages, and most of those who did were getting old. The breezes that blew up the mountain from the ocean five miles away kept the reservation cool in the summertime. The air was always clean with the fresh smell of tall redwoods.

Mabel and Charlie moved to Fulton, a small farming com- munity just north of Santa Rosa, and it was there that Charlie got sick. He was working for a farmer who raised cattle and sheep. He and Mabel rented a small house next to the fruit stand by the railroad tracks that led to Santa Rosa. The prob- lem started slowly, pains in the chest, but before long the medical doctors told Charlie he could no longer work. "What are we going to do now?" he asked Mabel.

"I'll get you on at the apple cannery in Sebastopol," Essie told Mabel. "I work as the foreman there. Think you could do it?"

"Sounds like when I used to clean the lettuce," Mabel an- swered.

It was seasonal work, but it more than kept Mabel and Charlie afloat. Between the small amount of money they had managed to save over the years and Mabel's earnings from her cannery work and basketry, they were able to make a down payment on a home in Santa Rosa. It was on Robles Avenue, west of town: a modest two-bedroom place badly in need of repair and smelling of goats from the goat keeper

who had lived there. They cleaned and painted, trimmed the shrubs and old roses outside, and next to the front door they put a wooden sign that read McKay.

Sometimes Charlie felt bad that he wasn't earning money for the household. "I broke my promise to you again about taking your money," he sighed. "What am I going to do?"

"You're gonna keep cooking and looking after the boy just as you been doing," Mabel answered.

And Charlie did cook, and each morning he got Marshall dressed for school. And every afternoon he met Marshall at the bus stop and walked him home. He never missed a day, even as his health continued to deteriorate.

Sometimes Mabel drove him and Marshall up to Kashaya with her. She drove up there quite often to work with Essie in the Roundhouse, performing annual ceremonies and doctoring the sick. Mabel found herself doctoring as much or more than she had before. People from the lake and the Sacramento Valley found her now that she was settled in Santa Rosa. And the Kashaya people used her services regularly, with and without Essie. She was always on the go. Sometimes she used her cousin from Middletown to interpret and sing for her. Sometimes she worked without an interpreter, explaining in English what her patients needed to hear. Sometimes she didn't even have a singer. She had to just get up and go. But there was always time to relax at Kashaya. Charlie could smell the fresh air and watch the birds in the trees. He advised Essie and Sidney's neighbors about what to feed their horses, and he spent hours sitting on the Parrishes' front porch watching the light-colored Appaloosa across the yard eating oat hay and swatting flies with its short, almost useless tail. And he waited there on the porch for Marshall to come in from the woods, where he roamed with Kashaya

children his age. "What'd you see, son?" Charlie always
asked.

But the mood at Kashaya began to change. Mormons moved in. They had a great line: "You Indians are the lost tribe of Israel." Everyone bought this bill of goods, even Essie and Mabel, who saw no conflict between their religious activities in the Roundhouse and what the Mormon missionaries were saying. "It's all the same," the missionaries professed. But it wasn't all the same, and the missionaries weren't telling everything. After some years, the missionaries told their Kashaya congregation, who had converted and had been baptized, that they must stop their "Indian" religion. "It's devil worship," they said.

The tribe split in two. The last close-knit traditional Pomo community crumbled. Family against family, sister against sister. Those who stayed with Essie and those who turned against her. Mabel couldn't believe it. The Roundhouse was less than half full now. Many of Essie's dancers and singers cursed her Dream. Doors were locked, shutters pulled completely down. Arguments. Fistfights. Prophecy, Mabel told herself. Essie's sad words that once seemed unbelievable.

And it was during these hard times that Mabel lost Charlie. His condition had so worsened that he had difficulty getting from the kitchen to the bathroom. One morning, terribly out of breath, he asked Mabel, "What's gonna happen to the boy?" He was sitting in a chair in the front room looking pale, gray. "Don't worry, he'll be fine," Mabel answered and then went into the kitchen to finish the morning dishes. When she came back, she found Charlie slumped in his chair. She knew by his eyes, his gaping mouth, what had happened. She cleaned him and changed his clothes right there in the chair. She parted and combed his gray hair. When the

undertaker arrived, Charlie was sitting in his chair, looking the way he always looked, respectable.

Mabel seldom cried, but at Charlie's funeral she wept openly. She took Marshall's hand and cried. Marshall, who was about thirteen, comforted her. "It'll be all right, Mama," he said. It was a large funeral. Indians from the Sacramento Valley and Lake County showed up at the Memorial Park Cemetery in Santa Rosa. Kashaya Indians. Indians from Ukiah and Hopland. Relatives. Even many of the ranchers Charlie had worked for. People put up great amounts of food at Mabel's house. They sat with her until the late hours of the night.

In the days ahead, she put things in order. She cleaned out Charlie's clothes and belongings from the closet and garage. She reviewed her finances and figured how she would keep up the house and keep Marshall fed and clothed. Things wouldn't be that different, really; she had been managing the family's affairs for the last several years, since Charlie had become sick. She was busy always. Doctoring. Weaving. The cannery. Looking after Marshall. But sometimes, in the middle of the day, when she was home and standing by the kitchen sink, she caught sight of the family dog out the window. The old shepherd-collie mix would be sunning himself on the porch, lying next to the rickety wooden chair where Charlie used to sit.

The following spring Mabel spent a week with Essie. It was during Easter vacation, when Marshall was out of school and on a trip with a friend and his family. Mabel went to Kashaya with little in mind except to visit her friend. Essie's annual spring Strawberry Festival was at least a month away, and neither Mabel nor Essie had been called by anyone to doctor. The women would have time to themselves. As it

turned out, Sidney, Essie's husband, was away on a job. Essie's youngest daughter, Vana, was staying with relatives in Sebastopol. So Mabel and Essie even had Essie's home to themselves.

They spent long hours visiting. Mabel saw just how uncomfortable Essie's life had become at Kashaya. Mormon converts yelled out "Devil" when they saw her on her porch or in her yard. She told Mabel that she often had a hard time rounding up enough people, even in her own family, to perform her ceremonies. "It is my Dream," she told Mabel. "These costumes, my things must be danced. How else are we going to be kept alive?" They were talking over a cup of coffee at Essie's oilcloth-covered kitchen table.

"You know," she said, looking at Mabel, "I will go before you. I'll leave this earth before you. Then you must lock the Roundhouse. There will be no more true Dream Dances here. A lot of fakes will come out, dance around. No more true Dances until the next true Dreamer comes. But no one who knew me will be that person, that Dreamer. That person will come in the future quite aways, I guess. Anyway, you'll be the one to lock the Roundhouse. Close to when that time comes I'll explain more to you about that. There will be a few still faithful to me, in my family. You'll take care of them. You must still give thanks. Give a Strawberry Dinner each spring and an Acorn Dinner each fall. Even without the dancing. Just pray and bless that food. Things can go on like that. Do you understand what I mean?"

"Yeah, I do," Mabel answered.

That afternoon they drove east down the mountain to dig sedge along Dry Creek. The creek was low, and the sandy soil was still moist from the spring rains. They found a patch of ground where the digging would be good, where the fi-

brous sedge roots grew straight and long under the sand. They sat down with their handpicks and garden trowels and began working. They worked a long time, digging and cutting, piling wet soggy roots on newspapers and gunnysacks. When they took a break, sitting back and drinking warm coffee in plastic cups from the tops of their thermos bottles, Essie told about her Dream. "They're going to build a dam here one day soon. Where we're sitting will be hundreds of feet under water. This last good sedge-picking place will be no more." Mabel knew to believe Essie, just as she knew to believe what Essie had said about her own end on earth, about locking the Roundhouse. But sitting there in that afternoon spring sun, Mabel felt something timeless, endless, something familiar and forever about digging roots by the water with another woman.

Mabel's baskets were displayed at the Smithsonian and at other prominent museums throughout the country and abroad. She was asked to teach basketweaving classes. She was sought after as a speaker at museums and universities—not just to talk about her basketry, but about her doctoring and culture. "What am I going to say?" she asked the spirit. "I never even went to college." "You just get up there and talk. I'll put it to you."

So Mabel taught classes. She spoke before audiences of all sizes at museums and universities. She asked her mostly non-Indian basketweaving students to observe her rules. "No menstruating, liquor, or drugs when weaving," she told them. "The moon time for women is a time for them to relax, leave things alone." When museum or university audiences wanted to know how she thought up her basket designs or

what tools she used to make her miniature baskets, she answered, "The spirit," and then talked about her Dream. When they wanted to know about her Dream and her doctoring, she talked about her baskets. "Spirit told me to make basket for that," she said, "a basket with design for my spitting out the pain." They didn't get the answers they wanted or expected, but something different, something always Mabel.

Once Mabel sat before a group of psychiatrists and other social scientists who wanted to know about her doctoring and her "other states of reality." At one point during their conversation, Mabel told about the medicine man who got out of jail by turning into a fly or a hummingbird. "People say he flew through the bars," Mabel said.

"Do you believe that?" one of the scientists asked.

"No," Mabel answered. The panel of scientists sighed relief, thinking for a moment that maybe Mabel wasn't so different after all. Then she said with a slight chuckle, "I believe he went down the toilet."

Another time Mabel spoke to a group of Stanford medical students who wanted to know about "ethnic medicine" and how to work cooperatively with native healers. She prayed and sang a song, all of which lasted about five minutes, then sat down and talked about the dictates of her spirit and her doctoring. Suddenly she stopped and looked up, out to her audience. "OK," she said, "now who can tell me what I just said?" The students and their professors were quiet, stunned. "Ain't nobody got a word for me?" she asked finally and laughed. "I thought you wanted to know about healers." One student spoke up and paraphrased a portion of Mabel's presentation. "Pretty good," she said, chuckling. Another student interrupted the dynamic Mabel had established by

asking how she became a doctor. "Like you," she said, "long time studying." Later, toward the end of her hour with the students, she said, "You have to know me. How what I say, it turns out. And that's a long time. That's knowing me."

Despite the attention Mabel gained as an artist and public speaker, she never stopped working in the cannery. Not for twenty years. She never had more money than just enough for her and Marshall to get by. At home, out of the public eye, she worked. Long hours every summer and fall, sometimes ten hours a day, standing with other women along a conveyor belt in a hot, crowded room, grabbing apples, one after another, peeling them and cutting away bruises, making sure not a single apple passed by unchecked. After work, at night or in the morning, depending on her shift at the cannery, she was off, sometimes a hundred miles away, doctoring. Often she would get back just in time to change her clothes and make her shift at the cannery.

Her public audiences never saw her sticky, apple-smelling clothes. They never saw her traveling here and there to attend to the sick and troubled. She was always the neat-looking short Indian woman with dyed and coifed black hair, modish glasses, and a sweater buttoned neatly at her neck. Awesome, yes. She was strong, self-possessed, and she gave wild answers to their questions and told interesting stories. But just as Mabel was always more than Mabel, more than a neat-looking small Indian woman, so her stories were more than stories. For those who had lived them, they were miracles.

. . . Like the man who had gained a hundred pounds in two weeks. He had become so bloated he could not move off his bed. Edema from a damaged heart, the medical doctors said. No hope. He was drowning in his own weight. Mabel

sucked gallons and gallons of water out of his chest. Then she and Essie walked him around and around his front room. They worked on him for four days and four nights, until he was emptied of the extra weight. "You're cured," Mabel told him then. "Your heart has been fixed. You be better to your wife and children. No more drinking that beer. It works in that mean heart of yours to kill you." She told him where to dig angelica to protect himself. She gave him a prayer. "You say that prayer, and each month at the same time you put up a good dinner for your family. You'll live that way."

And there was the young man from Santa Rosa who was possessed by an evil spirit. In the middle of the night, when he was sound asleep, the evil spirit grabbed him around the waist and tossed him out of bed. Glasses of milk and Coca-Cola were slapped out of his hands. Once, when he was at the ocean with his friends, the evil spirit threw him out of a parked car. He was thrown onto the road and then back against the car. His family was Catholic; they didn't believe in the Indian ways. But after the local priest could not exorcise the bad spirit, they went to Mabel. She took him up to Kashaya. She and Essie walked him into the Roundhouse and tied him to the centerpole to keep him from flying all over the room. They prayed and sang, tricked the evil spirit to sleep so they could get hold of its heavy invisible form and toss it from the Roundhouse. Then Mabel cut the young man loose from the centerpole and handed him a small green stone. "Keep this with you at all times," she said. "It has my song on it."

And there was the woman from Lake County who needed an operation for stomach cancer. The doctors showed her the dismal-looking X rays. She went to Mabel pleading for help, and Mabel lifted long black roots, like the roots of a plant,

Medicine Woman

from her stomach. The woman told her doctors in Lake County that she had been cured. They didn't believe her, but agreed to take X rays again. The new pictures didn't show a trace of cancer, nothing out of the ordinary.

Once a young man from the Sacramento Valley came to Mabel needing a different kind of help. He was a singer and a dancer, a Wintun man from east of Rumsey. He explained to her that the dance leader of his local group of dancers had passed away. He wanted to keep the dances alive for his children. But he didn't know what to do, since the leader had died suddenly and had left no instructions for continuing or ending the dances. They had never started a dance without the leader's blessing song. "Well, I can bless you," Mabel said. "I can bless the flicker heads and give you a blessing song." The man couldn't believe his ears. It was the same song the leader had sung time and time again. "How did you know it?" he asked. "I knew that man," Mabel answered. "I heard him sing when I was a young girl in Cortina. He came there and danced. It was part of my adoption there. Now you learn it. It's time for you. I'm giving it back."

And there was the time something strange happened with Essie. A man went to someone in Healdsburg and said he was looking for Essie, that he was going to kill her. He was angry about something she did or didn't do. Mabel didn't know what. Someone called her and tipped her off. "Is Essie with you?" the person asked over the phone. "No," Mabel answered. "Well, this man says he's going to kill her. He'll probably come to your place looking for her. Stay put and don't answer the door."

But Mabel did no such thing. She got in her car and went looking for Essie, who was living at the time on a ranch in Windsor, just north of Santa Rosa. Mabel drove to Windsor,

to where she thought the ranch was, but she couldn't find the place. She couldn't find the big oak tree that marked the road into the property. So she ended up driving around and around the countryside in circles. She prayed, sang songs, but still couldn't find her way. If only Essie had a phone, she kept thinking. Then, just before she turned back to Santa Rosa, she noticed a car following her. It didn't follow for long though, and Mabel noticed that the driver pulled off the road alongside a grape vineyard. She figured he was a Mexican; a lot of Mexicans were in the vineyards cutting grapes at the time. But he wasn't a Mexican. He was the Indian who wanted to kill Essie.

Mabel found this out later that night, after the man was arrested by the police. Essie came to Mabel's with Sidney and told Mabel what happened. "We saw you from the house," Essie said. "We saw you driving around and around in circles out there. Well, you see, when you started back to Santa Rosa with that man following you, we got out and drove the other way to Healdsburg. We called the police and they got him there with a loaded gun and a bottle of wine. You saved me, Mabel."

"Hmm. I only thought I was lost."

And there were the miracles I myself witnessed.

Like the time Mabel sucked a wiggling creature from a woman's swollen eye. It was the first time I saw her doctor. I was nineteen or twenty years old. Before, I had always left her house when the patients came. I didn't really want to see her doctor this time either. But a professor friend of mine from school had asked if I could arrange with Mabel for him to watch a healing ceremony. I wanted to impress him. I asked Mabel. She said OK. But as it turned out, my friend saw very little. Mabel sat him in a chair behind her, so that he

was unable to see her work over the woman laid out on the couch in front of her. She sat me right in the line of action, where I had to see what she was doing.

Susie Gomez, Essie's sister, sang for Mabel. Essie and Sidney were there too. Mabel smoked pipeful after pipeful of angelica root. The candlelit front room of her house filled with the sweet, damp smell of angelica smoke. Something like celery, if it could burn. She called the spirit, prayed in her language, and danced and danced while Susie sang the doctoring songs and kept beat with the shiny elderberry clapper stick. Then Mabel sat down in her chair opposite the patient. "Near as I can say in English," she said, "this woman has a polliwog-trout salmon in her. She got it when she was a young girl, when she went into the river at the wrong time of the month. It's been living in her all this time. It's why she's never had any children. It's why her eye is big. It's why the white doctors can't help her."

Mabel was quiet a long time. Then she started singing again and Susie picked up the song. She leaned over the woman on the couch, started rubbing her forehead, then put her mouth over the woman's eye. She rose up, grabbed her basket from the floor, and spit into it. She sang a few more songs. Then we all got up and turned four times. "Now," she said, "those who want to witness this poison, come here." The professor jumped up, but she was holding the basket toward me. I went forward and looked. In the basket I saw a salamanderlike creature. Maybe something more like a fish. It was about an inch and a half long, red with a black stripe down its back and two bulging black eyes. It was moving, its tail flicking back and forth. "Now you've seen what people don't believe," Mabel said. And then she turned with the basket in her hand and went to the back of the house. I heard her flush the toilet.

Medicine Woman

And there was a Mexican friend of mine who lived in Santa Cruz. I took Mabel to meet his mother, who was a *curandera,* a healer, like Mabel. The two women wanted to meet each other. My friend translated for his mother, who spoke no English. The tired-looking Mexican Indian woman was nearly blind in one eye; her eye festered behind heavy lids, as if she was squinting. I thought maybe she wanted Mabel to doctor her. But then Mabel began complaining about her arthritic knee and shoulder. My friend's mother placed her hand on Mabel's knee, just briefly.

About two weeks after the visit, I saw my friend. He was angry. "Why did she do that?" he asked.

"Do what?" I asked.

"She tried to test my mother; she played with her."

"Who?"

"That Mabel. She tested my mother, man. Why'd she do that?"

I thought of the woman's hand on Mabel's knee. "You think Mabel was testing her?" I asked.

"Ah, c'mon. My mother was upset, man. They are both *curanderas,* why the games, man? My mother believes in Mabel."

When Mabel and I left my friend's house that day, Mabel had mentioned that my friend's mother had great power in her hands, and that my friend did also. She said his mother would lose both eyes if her son did not help her keep up her traditions. "He doesn't believe," Mabel said. "He doubts. He drinks. He puts on a good show, that's all."

Later, after my angry friend left, I thought, yes, Mabel had found out about his mother's hands. She had talked the poor woman right into it. Mabel had hoodwinked her.

I phoned Mabel and told her what my friend had said,

how excited he was. Mabel laughed. "Sounds like he believes now," she said.

And there was another trip to Santa Cruz, after which Mabel had to doctor me. I had driven her to the university, U.C. Santa Cruz, where she was to speak at a multicultural event. It wasn't long after the incident with my friend and his mother. I was living in Santa Cruz at the time, teaching writing courses at the university. I was just over thirty, a little tired of teaching composition, and contemplating going back to Stanford to complete a Ph.D. The trip seemed routine. I picked up Mabel in Santa Rosa and got her to the designated campus auditorium on time. She spoke about her baskets and told various stories. She also spent some time talking about following rules and mentioned the rules concerning menstruating women. This won't go over big among the feminists in the room, I thought to myself. They might not understand what Mabel means, or agree with her even if they did understand. It is the time for a woman to rest and relax. Men and other women must cook for them, wait on them. It is a special time, an honoring time, a time for women to respect themselves and be respected by others.

When Mabel finished, a Puerto Rican woman sitting next to me stood up to give her presentation. She was a good friend of mine. She bent over and hugged me. "Wish me luck," she said. Then she hugged Mabel, who was on her way back from the podium. Five minutes into her presentation, the woman fainted, collapsed to the floor. Mabel leaned over to me and whispered, "She shouldn't have touched us. She's on her moon."

An emergency medical team revived the woman. She seemed well again. During the luncheon that the university held for the guest speakers, the woman came bounding up

Medicine Woman

to me. "What happened?" she asked, out of earshot from
Mabel. "Someone said that lady hexed me, that she's a witch." I felt embarrassed, awkward. I tried to repeat what Mabel had said on stage. "I have my prayer basket with me. And maybe even touching me can make you faint," I said.

"Do you believe that?" the woman scoffed. "I'm a Marxist, I don't believe anything like that."

I didn't say anything. I didn't know what to say.

"Why do people say that lady hexed me?"

What difference does it make if you don't believe anything like that? I thought of answering but didn't.

On the way home, I had an attack. My eyes swelled up, as if I had hay fever. I couldn't breathe. I kept sneezing. I had to pull off the road. Mabel sang a song, and I was able to see well enough to drive. "You been poisoned by that moonsick problem," she said. "That basket I gave you is my rule, my way."

When we walked into her house, she motioned to the couch. I knew what was happening. I was frightened, uneasy. What *was* happening? How did I get into this? Who is Mabel?

I rested on the couch with a blanket over me. Incredibly, her songs calmed me, even the shaking of her cocoon rattle. I felt sleepy. She leaned over and with a mouth that felt like cool running water, took fluid from each temple, my right and my left, until my eyes were clear and I could breathe easily. "Now do you believe?" she asked.

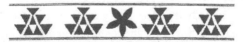

Medicine Woman

Prayer Basket

*The spirit won't go away. It won't
disappear or hide someplace. It's
everlasting.*

Late in 1975, after the fall apple crop, Mabel retired
from the cannery. She was sixty-eight years old. She
had worked cutting and peeling apples for twenty
years, long enough to earn a pension. She had paid off the
house on Robles Avenue and provided her son Marshall a
comfortable life. Not long after she retired, she quit driving.
One night, on her way to doctor someone, a woman ran a
stop sign and hit her. "You don't drive anymore," the spirit
told her. "If people want you, they can come for you." She
had her car repaired and gave it to Marshall. Marshall had
become a welder. After securing a job with the Navy, he
moved to an apartment of his own in Santa Rosa and com-
muted to Mare Island, the navy port near San Francisco.
Mabel found herself alone, but she was hardly lonely.

People came for her. They came for her to doctor the sick.
They came to order baskets. They came to ask questions, just
to meet her. By this time in her life, her list of credits and
honors seemed infinite. World-renowned Pomo basket-

maker. Traditional Pomo medicine woman. Honored elder at countless American Indian events. Distinguished speaker at colleges and universities throughout the country. Governor Jerry Brown appointed her to the first California Indian Heritage Commission. Foreign diplomats arranged to meet her during their visits to San Francisco. Her phone rang incessantly. A steady stream of visitors knocked on her door.

Still, Mabel managed to live simply. She wasn't taken with all the attention. She wasn't impressed by those who were powerful and famous. Years later, when Pope John Paul II requested a personal meeting with her during his visit to Northern California, she asked, "What's he want to do, bless me?" An official from the Archdiocese of Monterey had telephoned me to see if I could arrange the meeting between Mabel and the Pope. I tried to explain the situation to her. "You see," she said, "he has his rule and I have mine." Then she capitulated. "Well," she said, "you could bring him up and maybe we could go to lunch. Happy Steak. All you can eat."

By this time Mabel was the last of her tribe, the last to know the Lolsel Cache Creek Pomo language and history. Her mother and uncles had passed away. Frances, her sister, and her cousins in Cortina and Colusa considered themselves Wintun. When she spoke her language, only the spirit understood. And Essie. "Essie knows because she knows the spirit," Mabel said.

Then on a warm July afternoon in 1979 Essie Parrish passed away. "On the day I die there will be rain and thunder," Essie had said. "Later you will see red lightning." Nobody could believe it, not on a day in the middle of summer. But early that evening, after the undertakers had left the house with her body, the sky clouded, darkened with rain

and thunder. Exactly one month later, lightning struck over the reservation homes and above the Roundhouse, and it was red, unlike anything anyone had ever seen.

Essie had been sick a long time. A few years before she passed on, she appeared in Mabel's Dream. "You must come up now and see me for the final instructions." So Mabel packed and found a ride to the Kashaya Reservation. For two weeks she spent day after day, night after night in the Roundhouse with Essie. No one knew what they said, what they did. But Mabel knew what to do when the time came. Essie was to lie in state in the Roundhouse for four days. Her medicine poles, both of them, were to lie with her, and she was to wear her white dress, sewn now with the blue lining. After the fourth night, she was to be buried in the small Kashaya cemetery and the Roundhouse was to be locked until it fell or until another Dreamer came to open it. That's how the funeral was handled. "The people with the white dresses, tear them up," Mabel said. "No more dances. Only the Strawberry picnic in the spring and the Acorn picnic in the fall. And the few songs she left for protection." She locked the Roundhouse, turning the key in the padlock over the doorway. Then she handed the key to Paul, Violet's husband, Essie's son-in-law, and said, "Throw it in the river someplace where nobody can find it."

It was after Essie's death that things changed for Mabel. She had already turned over her home to Marshall and his new wife, Electa, and had moved into an apartment on Mendocino Avenue in downtown Santa Rosa. So it wasn't the move to a new place and the fact that she wasn't driving or working in the cannery any longer that made things different. "Now, after Essie's going on, you will retire from your doctoring for four years," the spirit said. "You keep weaving,

but that's all for now." "I can't doctor," Mabel told people.
"It's different now."

Not long after Essie passed away, Mabel started smoking.
I couldn't believe my eyes the first time I saw it. We were
eating at a restaurant in the local shopping mall. She pulled
out a pack of cigarettes from her purse, used a silver lighter,
and puffed as if she had been smoking for years. Maybe she
had been smoking for some time; I wasn't sure since I had
been living in Los Angeles and had just recently returned.

"Got to counteract the poisons around me," she said mat-
ter-of-factly.

"But it's bad for you," I protested.

She laughed. "Maybe so. Things change."

"What do you mean?"

"Like my retiring from my doctoring. Spirit said, 'You're
gonna slack.'" She set her cigarette in a glass ashtray the
waitress had set on the table. She looked at me through her
glasses.

"But you'll doctor again, won't you?" I asked.

"Yeah, but maybe not sucking. Maybe sucking, I don't
know. It's hard work."

She picked up her cigarette, puffed, and looked around
the crowded restaurant. "Lot of peoples want to write my
book," she said, setting the cigarette down. "This girl, she
starts recording me. She wants to know about the spirit. But
how can she know about it? She doesn't know me. So I fire
her. This man, he come too. He come with the tape recorder.
I say, 'OK, let's start.' Then all he does is read from some
book about the shamans. 'I'm no shaman,' I say. So him I fire
too. They don't know."

"Well, someone should write a book about you . . ."

"Why?" she asked, cutting me off.

Prayer Basket

"Because of your life, who you are, all the things you've done."

She started laughing again. "Oh, maybe so, I guess. Sounds like a idea, I guess. You could do that. You went to college."

She kept chuckling, her eyes twinkling, which is why I didn't know how to take her suggestion just then. Was she serious about my writing her book or poking fun at me for something I said?

She slapped a few quarters on the table. "Benson and Hedges," she said. "The machine is over there, by the wall."

Mabel had seen so much of her Dream come true. People. Places. Things that happened. Storms. Earthquakes. The assassination of Robert Kennedy. "I wait and see," she said. "I believe." One day a group of young Indian activists called on her to help them protest the construction of Warm Springs Dam on Dry Creek. "You're a sacred woman and a basket-maker," they chimed in outside her door. "You need that place to dig sedge roots. Come with us." So Mabel went and joined the large gathering of protesters collected before a row of tractors and cranes. County sheriffs swarmed overhead in half a dozen helicopters. Journalists ran about snapping pictures. Scott Patterson, a local anthropologist, took a picture of Mabel standing alone in front of a yellow Euclid earthmover the size of a four-story apartment building. She wasn't even a third as tall as the enormous vehicle's front tire.

The photo appeared everywhere, in calendars, on museum walls, splashed on leaflets announcing American Indian and environmentalist meetings and events. The picture made a statement, and Mabel was glad of it. But that day at Dry Creek, amid the noise of busy people and hovering helicopters, she thought of Essie, of the quiet time she and Essie sat

digging sedge on that warm afternoon in spring. She knew the protesters' efforts would come to no avail. Not right there, anyway. Not for Dry Creek and the canyon. Essie's Dream, Mabel thought, seeing the sedge and the willows along the creek and the chaparral on the canyon slopes under hundreds of feet of water.

Mabel thought of Essie often, and when Essie's daughter Violet came to visit Mabel, the two of them talked for hours, trading stories, remembering Essie in each of their lives. "You know," Violet said one day, "you should come live with me and Paul. Aunt Mabel, you'll have some peace up at Kashaya. Too far for people to keep coming for you." "I am getting older," Mabel responded. "It would make me feel good," Violet said, "like having Mom around." Mabel agreed.

So Violet prepared a bedroom in her trailer home for Mabel. She vacuumed, washed the curtains, cleared closets. Paul packed Mabel's belongings in cardboard boxes and hauled them in several trips from Santa Rosa to the reservation. Mabel enjoyed the fresh air, the space. She enjoyed visiting, sharing meals with Paul and Violet. She traveled with them on short trips to Gualala for groceries. She rode with them to Santa Rosa to visit friends. Paul drove her to pick herbs. He dug angelica for her; only a man can dig angelica. She saw again and again why Essie spoke so highly of her white son-in-law. "Kind as a old-time Indian," Essie used to say.

Mabel visited with many of the Kashaya people. They seemed friendly enough. But all was not well, which Mabel eventually got wind of. "How come this outsider is living at Kashaya where she don't belong?" "Yeah, she's the one who come in here and closed our Roundhouse." "And another

thing, she's poison. I was talking to someone and they said she's from that white snake poison place. She's no doctor. Look, she don't even pretend to doctor no more. She's just here to poison us off, finish what Essie was doing."

"Don't listen," Violet told Mabel. "They're just jealous of you. They always have been. They're jealous of Mom. They don't believe in her and the Dream. They don't believe in you."

"Yeah, Aunt Mabel," Paul said, "they should be happy. They should be saying, 'We're lucky, we have a woman here to pray for us.' "

But neither Paul nor Violet could convince Mabel to stay. "Not good to be where people don't want you," Mabel said. "Not good for you or me."

"I know you was going to say that, Aunt Mabel," Violet said, beginning to cry. "Those darn fools."

Before Mabel moved back to town, she and Violet and Paul visited Essie's grave. They carried bouquets of brightly colored plastic flowers and placed them on the grave. Essie is buried next to Sidney under a large tan oak tree. *Cisq qhale,* "beautiful tree" in Kashaya. The mounds of dirt over each grave are surrounded by a row of iridescent abalone shells and covered with an abundance of plastic flowers. "Keep the graves beautiful," Mabel said. She turned to Paul. "Might be good idea to build a fence. Keep people here from harming this place."

They found Mabel an apartment in Santa Rosa, on Dexter Street, just off Mendocino Avenue. It wasn't far from where she had lived in an apartment before. But it was more convenient, a stone's throw from a 7-Eleven store and the bus. The junior college with its rose garden and oak-covered lawns was just across the street. She settled in. She wove in the

mornings, and if she didn't have visitors in the afternoon, if she wasn't taken out to lunch, she got on the bus and explored the town. She walked through shopping malls, stopped here to get a sandwich, there to get an ice cream cone. She felt like a young woman on the loose with things to see and no one to stop her.

Once when she was downtown, across from the Bank of America and Old Courthouse Square, she spotted an old Indian on the street corner, a man she had first seen years ago, when she was living in Ukiah. Like the woman there who had poisoned Mabel's friend with dried red powder, this man crept around the buildings and brush watching Mabel. He never bothered anyone though. He lived alone with his sister, people said. Mabel had once spotted him on the same street corner when she and Essie were shopping in downtown Santa Rosa. They paid little attention until he appeared right behind them at the soda fountain in Thrifty's and again an hour later in a men's store where Mabel was buying a shirt for Marshall. "He's got power to track people," Essie said. "Let's get out of here. I don't like it."

Now Mabel watched the man as he set his eyes on her. He lifted his nose like an animal catching a scent. She turned and quickly made her way around the corner to the bus stop. Luckily, the bus came right away. Instead of getting off at Dexter Street, she rode the bus until it looped around Old Courthouse Square. From the bus, she saw the old man walking along Fourth Street, along the square, sniffing the air. Hah, she thought to herself. He's confused. He doesn't understand my power. Bus power.

Mabel was generally patient with people and their endless questions. If anything, it was her answers that made others impatient. But one group of visitors who came regularly to

Dexter Street annoyed her, so much so that she asked them to leave. They were students from the junior college. A few claimed they were Indian, part Cherokee. They wore beads and feathers, open leather vests showing their bare chests. "Is there a Indian dance going on someplace I don't know about?" Mabel asked when they appeared outside her door. They sat cross-legged on her spiral carpet and read to her from books about an old medicine man in Mexico who used peyote. "He's like you, Mabel," they said. "Hmm. Doesn't sound like it," Mabel answered from her chair. She fixed them coffee and served crackers and hot buttered toast, just as she did for everyone who visited her. One day she watched as they pulled up in front of the apartment building. They got out of the car in their beads and feathers, open vests, men and women alike. Only they didn't come up to her door right away. She opened her window and smelled the sharp odor of marijuana smoke wafting in the air from the cigarette they passed back and forth to one another. "You don't respect me," she told them after they knocked on her door. "You don't even know who I am when I tell you."

She had two grandchildren now. Rebecca, who was about four, and Dillon, who was just a baby. Both children were adopted. Rebecca was blond and blue-eyed. Dillon was an Indian, dark and square. Mabel often babysat the children while Electa shopped and ran household errands. She and Marshall worked hard. They sold the place on Robles Avenue and bought a larger home in a pleasant neighborhood west of town. Mabel loved the children. She took Rebecca around the corner for an ice cream cone every time the girl visited. She told her stories, bought her dolls and toys to play with. She rocked Dillon in her arms, put him to sleep with the same Lolsel lullabies she had sung to Marshall, the same calming songs Sarah had sung to her.

Prayer Basket

It was for Marshall and his family that she moved back to Rumsey. Each adult descendant of the Rumsey Wintun tribe was provided a new HUD home at low cost. Since Marshall was the natural son of Mabel's Wintun sister, Frances Lorenzo McDaniel, he was entitled to a home as long as it was occupied, of use to him. At least that's how Mabel explained the situation. "I have to go live in it so it will be there when Marshall wants it," she said. People said she was simply going back to Rumsey to retire, back where she started. She's getting older, they said, and pointed out that Marshall and his wife had just purchased "a home on the hill" in Benicia. He would hardly ever want a modest HUD home on the reservation.

At first Mabel missed Santa Rosa with its buses and stores. She missed the constant flow of visitors and the passersby on Dexter Street from the junior college. She had lived in Santa Rosa for almost thirty years, and she had lived away from Rumsey for nearly fifty. She had returned only for funerals and brief visits. Now she found herself again hearing the valley meadowlarks at noon and the noisy mockingbirds during the hot summer nights that were seldom any cooler than the days. From her porch, she could see the highway below, where she remembered the dirt road. Beyond the highway, tomato fields, where she remembered fruit orchards and vineyards. And beyond the tomato fields, the western hills that were the same. Not much had changed in Rumsey, no population explosion, no housing developments. Eventually the quiet of Rumsey with its birds and crickets and open fields settled in her so that it seemed home once again.

It wasn't that her life was over, that everything stopped. She kept weaving and regularly taught classes near Davis, just fifty minutes away. She still traveled to museums and universities to talk. And while she wasn't as accessible as she had

been in Santa Rosa, people made the long trip to Rumsey to see her. It was just that now she had more time to rest between this person and that trip. She had the space that her age demanded.

And she had Frances, her sister. They became inseparable. Frances accompanied Mabel on trips and to classes. She sat with Mabel when visitors came. Frances lived just across the road, and although her grown children lived nearby on the reservation and visited her frequently, Mabel provided just the kind of company Frances had missed and badly wanted. Someone closer to her age, someone who shared the same mother and grandmother. They talked about Daisy and Sarah and what they remembered about Rumsey before Mabel left. And they talked about all that had happened to them after Mabel left, the people they met, the places and things they had seen. They dug sedge roots and cut willows along the creek. They took trips to Lake County for redbud. They sat side by side at art shows and museums, two sisters, two weavers, one a Wintun, one a Pomo.

Sometimes Frances teased Mabel. "How can you be Pomo when you grew up here in Rumsey? Let's hear how you speak Pomo." So Mabel would say something in the Lolsel Cache Creek Pomo language, and Frances would be at a loss. "OK," Frances would say in English. "Let's go back to Wintun. I can't understand you." Then Frances began to hear the Lolsel language in prayers and songs, for Mabel had started doctoring again.

Her four years were up. Slowly, she took in a few patients. "You only pray over them, use your songs," the spirit told her. "But I see the sickness," Mabel answered as she sang over her patients. "I want to suck the sickness out." "Maybe later, not now. Trust the songs to do that." Now and then

Mabel did suck out a patient's pains. She said she didn't have enough faith just praying and singing, that the spirit allowed her to suck. But it was hard work. Just praying and singing was hard. Singing and dancing sometimes for two or three hours straight exhausted her.

Once a friend of mine, who is a Mandan from South Dakota, brought her stepfather to Mabel. The old man was a doctor himself. He had trouble remembering things. He said that when he called his spirit, he would forget certain songs. The spirit would hover near him, just out of reach. "No good to me that way," the old man said. "I got to bring the spirit right next to me, get hold of it, or I'm no good." Mabel sang over the tall gray man on her couch. She kept a steady beat with her polished split elderberry wood clapper. She used her bone whistle, making a high-pitched whistling sound, like fierce wind in the trees. She danced, then sat down and picked up her cocoon rattle, which she shook slowly, softly. Not a sound in the room other than the shaking of beads inside the rattle. Softly, slowly. All at once the old man's arms shot upward, toward the ceiling. His hands were trembling, his fingers moving, each with a life of its own. His whole body seemed to rise, levitate, slowly until he was two feet off the couch. Mabel, sitting four feet away in her chair, was lifting him, lifting him with the steady beat of her cocoon rattle and everything she had left to give. Sweat ran from her brow; her face seemed so concentrated, her breathing so shallow, that I thought she would stop, sink beneath her work. I panicked. O God, I said to myself without thinking, please help her. Please help her. I thought just then that she was going to die. I wanted to sing, hold out my prayer basket, anything.

Then I saw her chest begin to rise again. Lift and fall,

slowly at first, then faster and faster, until she was panting like a swimmer just out of the water. She had made it to the other side of the river. Exhausted yes, but safe. I sighed relief and looked back at my friend's stepfather. He was resting on the couch, his arms folded comfortably over his chest.

"You'll be OK," Mabel said to the man. "You'll remember."

"I know," he said.

Later, after my friend and her stepfather left, I told Mabel how frightened I had been. "I didn't think you were going to make it," I said.

It was late, about two in the morning, and she was tired. Her face was drawn, her eyes heavy. Still, I wanted her to talk, to assure me that I needn't have been so worried.

"Hmm," she said and slowly reached for her pack of cigarettes on the table.

It was all kinds of things. One thing with the other. She was older and didn't have the strength to doctor as she had. Yet that was her life, what she had to do to live. Fewer patients came. Fewer people in the valley used her, and people in Santa Rosa thought she had retired from her doctoring. Some said it was just too far to drive. More and more, old ailments and pains began to plague her. Arthritis set in.

"You must keep doctoring," an old Wintun singing doctor told her. Mabel had asked Frances to call the doctor woman, who lived near Redding, over a hundred miles north of Rumsey. The woman sang and prayed. Mabel felt a sharp pain leave her back.

"That's from when that man, that *Moki* clown at Cortina, hit you with the fire stick," the doctor said. "That fire was living there, where he hit you, for all these years. Now I took it out. But you have other pains coming alive, working at you. You must keep doctoring."

Prayer Basket

While her body caused much discomfort, so did the grow-
ing tension on the Rumsey Reservation. Peace and quiet
were no longer to be found there. The construction and day-
to-day operations of the largest Indian bingo hall in North-
ern California on the Rumsey Reservation changed life for-
ever. Suddenly, people had steady jobs and money. They also
fought, family against family. Frances and her family became
entrenched in the battles over who was or was not in charge
and the whereabouts of certain moneys. Frances had less time
for basketweaving. Her conversations with Mabel centered
on the endless drama around the bingo hall. Cache Creek
Bingo, they called the place, after the creek that ran from the
hills above Lolsel into the valley through Rumsey.

"Don't think about it," I told Mabel.

She seemed bothered, distracted. She worried about her
sister and her sister's children. That was how I found her just
after her birthday in January 1988, when I started making
plans for a last round of formal interviews with her in the
spring. I was sitting alone with her at her kitchen table. It
was late, after midnight. A fire popped and cracked in the
cast-iron fireplace.

"You can't let it worry you," I repeated. "Keep doctoring,
like that doctor lady said."

She exhaled a cloud of smoke and set her cigarette in the
ashtray. "Spirit said I'm going to slack."

"But the doctor said to keep doctoring."

She picked up her cigarette as if to take a puff, then put it
out. "How you going to do my book?" she asked.

"That's what I always ask you," I shot out.

She gave me an admonishing look. Not the answer she
was looking for, I thought to myself. "I'm going to come
back in the spring, like I said," I told her. "I'll finish getting
the exact dates and figures that go with the stories."

Prayer Basket

She looked perplexed.

"You know," I said, "so I can get things right. I mean with your life, the story."

She focused. "It has nothing to do with dates and that. I don't know about dates. It's everlasting what I'm talking about."

"The story," I blurted, "it has dates." But I might as well have said nothing. She lit a cigarette and looked across the room. The same old merry-go-round, I thought. What was she up to? She seemed to want me to stay, to keep talking with her, but why? As always, she was telling stories. She had talked about Lolsel, something about her grandmother visiting Aunt Belle there. It was nothing new, nothing I hadn't heard before. For the first time it occurred to me that she might be lonely, that she was simply telling stories, talking with me to fill the empty hours of discomfort and old age. Frances had been tangled up with the bingo politics and hadn't been around as much lately. It didn't seem to matter what we talked about.

The previous time I had visited her, it seemed the same way. I told her how I had met my aunt, my father's sister, and some of my Filipino cousins. I told her again about how I found my natural family just a year ago, and which Indians I was related to. She half fell asleep, then said nonchalantly, "It doesn't change who you are, what you done in your life."

It struck me that maybe it never mattered what Mabel and I talked about. The point was that there was no point. Just friends, acquaintances.

"It's late," Mabel said.

"Not that late," I answered.

"You're tired," she said.

She rubbed out her half-smoked cigarette and slowly

Prayer Basket

stood up. She made her way to the hall closet and came back with a pillow and sheets and blankets in her arms. She went to the couch and made up my bed. I knew not to protest. I couldn't say "Let me do that." It would do no good. It never did. I suddenly felt like a fool, rude, thick-headed. I was tired. Give up, I told myself. Let go.

It took her longer, but when she was through, everything was in order: a fluffy pillow, fresh sheets, and a blanket turned back just so. "Don't let the bedbugs bite," she said, leaving the room.

A few months later I told Violet about that night at Mabel's. "It must've been hard for her to do that," Violet said. "You know, I was worried when Aunt Mabel moved to Rumsey. It just plain worried me."

"Now look," I said, "she can't hardly walk. I feel so bad."

"We all do," Violet said.

The two of us were on the way home, back to Kashaya, after visiting Mabel in Rumsey. No Salome Alcantra this time. No Indian doctoring. It was late in April, and during the past month, after that first trip from Kashaya with Violet and her cousin Anita to get Salome for Mabel, I had made over a dozen trips. Stanford University in Palo Alto to Santa Rosa to Stewart's Point on the coast. Kashaya Reservation eastward to Ukiah, on to Lake County, and finally to Rumsey. Then back again. At least a dozen times. Two more times with Salome. A few times with Anita and Violet. Then just with Violet.

This time it was late, the middle of the night, and I must have been tired and thinking of Mabel, which is why I told the story of the last time she fixed a bed for me. We were starting up the long winding road to Kashaya, up Skaggs Springs Road, past the Warm Springs Dam.

"I feel bad, too," Violet said. "Mom always said, 'Take care of Aunt Mabel.' I tried, but these darn fools up here. Oh, makes me so mad . . ."

"People," I said. "People."

"Greg," Violet said. "It's nice of you to do this for Aunt Mabel. And I appreciate you coming to get me."

She must have sensed that I didn't want to drive up the mountain. It would have been so much easier to continue south on Highway 101 from Ukiah into Santa Rosa. Often I left her off at her younger sister's place, in Santa Rosa, which was five minutes from Mary Sarris's, where I stayed before trekking back to Palo Alto. I thought she was simply flattering me and being gracious because she needed a ride home. She did in fact need a ride home, but, as I found out, she meant what she said.

I should have known better. So much had changed between us as we had gotten to know each other on our endless trips to see Mabel. We had gotten to know one another well. Long talks about families, family lines, our lives. I felt embarrassed, ashamed for having thought she complimented me out of self-interest, which is why I accepted her invitation to rest and spend the night at her place before driving back to school.

"I insist," she said at the sliding glass door of her trailer home on the Kashaya Reservation. "Now you get in here and sleep. You don't need to go back to your mother's to sleep. It's three o'clock in the morning. Now get in here and quit acting like a stranger."

The word *stranger* hit a nerve. I stiffened, then came through the doorway. She immediately started making a bed for me on her long sofa. Fluffy pillows, clean sheets, a blan-

ket. Same thing. Just like Mabel. Seeing Violet working over the sofa, I felt awkward, more ridiculous than ever. Like salt rubbed in the wound of my frightened, hardheaded life. Of course Violet meant what she said. She cared for me. *Stranger.* It was the word she had used a week earlier after we had gotten back from Mabel's. I kept thinking of that night as I lay on the sofa in Violet's dark living room. I heard an owl in the trees outside the trailer. Stranger. Stranger. Stranger. Stranger. It wouldn't stop.

A week earlier I had finished telling her about how I had traced my natural family. About locating an aunt here, a relative there, until I had the whole story, which I told her. About the sixteen-year-old girl from a wealthy family in Laguna Beach. Bunny Hartman. And how she fell in love with Emilio Hilario. Emilio Hilario, the boy all the girls loved because he wasn't like the other boys they knew. Emilio. Dark, dangerous, sexual. Emilio. Forbidden fruit. A Filipino kitchen worker's son. And that standoffish Indian woman named Evelyn. Emilio, exulted town athlete. Town nigger. He saw Bunny at midnight, in secret places. In his car, parked on those cliffs overlooking the endless ocean. Endless. Infinite. On and on, until Bunny was pregnant and her embarrassed mother picked a spot on the map where the two of them might hide until it was all over. Santa Rosa. Sonoma County, where that standoffish Indian woman came from. But who knew, or was thinking of things like that? Anyway, it was only until things were over. But things didn't get over, not according to plan. Not clean, duty-free. After the baby was born, Bunny needed a blood transfusion. The hospital made a mistake. They gave her the wrong type blood, and she died eight days later. Died eight days later and was se-

cretly buried in the paupers' section of a small out-of-the-way cemetery with nothing to mark her grave but an upside-down horseshoe.

"Her mother, my grandmother, told everyone in the family she'd fallen off a horse and died," I told Violet.

"Gee," Violet said. "How sad."

Anita was sitting at Violet's table that evening also. Paul, Violet's husband, was on a job in Santa Rosa.

"So when did you find out about your Indian identity?" Anita asked, a cigarette poised between her fingers.

"Only a couple years ago," I answered. "See, I found out about my mother, Bunny, about fifteen years ago. My mom, Mary Sarris, told me she remembered the bracelet on my wrist when she took me home from the hospital. They forgot to cut the bracelet off. It said 'Baby Hartman.' She cut it off and then saw an obituary in the paper for a Bunny Hartman. Sixteen years old, no other details. 'Yes,' Mary's doctor and the adoption attorney said, 'that was the baby's mother.'

"Anyway, after Mary told me that, I asked a friend of mine who was a nurse at Santa Rosa Memorial Hospital to look in the records and see what she could find. She called me up, shocked. 'I read the microfiche and saw the records on your mother. All over the pages were big black stamped letters saying DO NOT INFORM PRESS. They listed the cause of death as toxic uremia. But it's clear that was from the mismatched blood.'

"She gave me the name of the doctor. I went to him. At first, he acted as if he didn't know what I was talking about. Then he broke down. He said he had been trying to forget the case his entire career. 'I don't want to take you to court,' I said. 'I just want to know something about my natural parents.' He didn't know much, except that my mother's mother

had had parents in Newport News, Virginia. 'But of course they would be long gone by now,' he said.

"That's what I thought too. Then about ten years later, well, actually a few years ago, I met a guy who fancies himself a pseudo-detective. I told him the story. He located a great-aunt, my grandmother's sister, still living in Newport News. She was shocked. 'I thought Bunny fell off a horse,' she said. 'Well, you're talking to the horse,' I said.

"I learned Bunny was Jewish and Irish and German. My great-aunt told me I had an uncle in Monterey, only a couple of hours from where I was living near Stanford. I called him. We met in a restaurant in Santa Cruz. 'No way,' he said, seeing me for the first time. 'Bunny pointed to a five-foot-two Mexican guy where she kept her horses. She was five-one or two. You don't put a five-two and a five-two together to get a six-two. You remind me of this big Hawaiian-type guy I used to take notes to for my sister. After school I used to trot out on the football field where he was practicing. He was a big guy. Dark.' 'What was his name?' I asked. 'Well, they used to call him Meatloaf, but I think his name was Emilio. Try Emilio. Go look in the yearbooks. I don't know a last name.'

"I asked him to tell his mother, my grandmother, about me. Which he did. But she was less than thrilled. Her secret was out. She wasn't real interested in meeting me. Anyway, I went down to Laguna Beach, to the high school, and started paging through old yearbooks. I found my mother's pictures right away. I had a last name. Then I got the yearbooks from a few years earlier—my father, or this Emilio, was older than my mother. I went down the pages, down the list of names. Seeing all the white faces, I figured there wouldn't be too many Emilios.

Prayer Basket

"Then I saw it. The name. Emilio Hilario. I looked at the picture and saw my face. Darker, yes. But my face all the same. I ended up interviewing over twenty people, and, yes, they confirmed that Emilio was my father. Other girls had gotten pregnant from him also. 'Oh, your mother loved him so, even as wild as he was,' her best friend told me. 'When I heard Bunny fell off a horse, I never believed it. I knew she was pregnant.'

"I missed meeting my dad by just a few years. He'd become a professional boxer, then a salesman. He did pretty well, but he was never happy. He drank. He died that way, at only fifty-two. Heart attack. But I met a half-brother. And my Filipino grandfather, I met him. He still lives in the same house in Laguna Beach where my dad grew up. He's the one who told me Grandma was Indian. He said her mother's father was an old man named Smith. Tom Smith. 'Tom Smith from just the other side of the Golden Gate Bridge,' he said."

Anita was excited. "So how did your grandmother meet your grandfather?"

"She left up here to go live with her sister, Juanita, in L.A. She met Grandpa there. He'd only been off the boat a year or so."

"Tom Smith," Violet said, leaning forward. "He was married to my great-grandma Rosie here at Kashaya. Yes, he was part Kashaya, part Miwok. And, yes, Evelyn . . . Her mother would be Nettie Smith. And Emily, oh . . ." Violet paused and started snickering.

"What?" I asked.

"Oh, this is so strange," Violet said to Anita, who had finally lit her cigarette. "Grandma Rosie used to talk about Emily, Nettie's mother. She had an Indian name, Emily did. I

forgot now." She looked to me. She was snickering again.
"You know why Grandma Rosie talked about Emily?"

"No," I answered. "How would I?"

"Well," Violet said and burst out in full laughter. "Gee, I can't talk." She contained herself finally. "Well, how do I say it, Greg?"

"Just tell him," Anita said.

Violet looked at me. "They shared the same man. Both of them had Tom. At the same time! Emily down there in Marshall, in Miwok country, and Grandma Rosie up here at Kashaya."

"Rosie didn't always say nice things about her," Anita chuckled. "Jealousy, you know."

"Tom Smith was a medicine man," Violet said, more serious now.

"Yeah, among other things," Anita quipped. She slugged me on the shoulder. "Guess it runs in the family."

Violet sat back in her chair. "Let's see, Emily and Tom would be your great-great grandparents. Oh, there's so much you can learn about this history, Greg. This genealogy, it's history, who we are."

"Just think," Anita said, "you were raised around Indians and didn't know you were one of us. Well, how do you feel now?"

"Great. Proud."

"That's not what I'm asking," Anita said.

"He still doesn't feel like he's got a family," Violet said. "That's why, Greg, you act like a stranger. Me and Anita been watching."

Anita pointed to her curled black hair. "We got antennas up here. We've been watching you."

Prayer Basket

"Well, Mary Sarris was good to me. I always kept close to her. It was my adoptive father who was bad . . ."

"You still feel like a stranger even there," Violet said. "It's in your behavior. We see. You're a stranger to yourself, who you are."

She was right. Even then, sitting at the table with her and Anita, I knew. Yes, I loved Mary. I considered her my mother; I stayed with her whenever I was in Santa Rosa. But among her family, my adoptive brother and cousins, I felt different, awkward. Not just because I was adopted, different-looking, darker (they are blonds), but because of my years going here and there, living on farms and ranches, with all kinds of people, white ranchers, Mexicans, Indians, Mabel. All that time escaping Mary's husband, George, until she divorced him—but by that time, when I was twelve or so, I was used to the countryside and the streets. I didn't go back until I was sixteen, when I decided I wanted to go to college.

Stranger. How it all came down to a single word. Violet and Anita knew.

And Violet just mentioned it again when she pulled me through her sliding glass doors.

I felt the sheets and warm blanket over me. The smell of Violet's last cigarette lingered in the room. It was dark, but the numerous family pictures on Violet's walls reflected whatever light came through the windows from outside. Above me was the large photograph of Essie in the Roundhouse. Essie in her dark floor-length gown sewn with abalone pendants. I looked. I couldn't really make out her face or even the details of her elaborate gown, but the medicine poles she held, one in each hand, were clear. Tall canes covered with figures of stars and crescent moons in the dark above me. It was quiet. The owl had stopped calling.

Prayer Basket

Around the first of May, Mabel started walking again. She used a cane, went slowly, sometimes unsteadily, but she could get here and there on her own. She made a beeline for the beauty parlor in Woodland, got her hair cut, dyed, and permed. She dressed up, collected together her willows and roots and a small display of her basketry, and taught a class in Davis. She took a trip to the California Indian Museum in Sacramento and met with the curator to discuss the details of a show in her honor. Long glass cases displayed her brilliantly colored feather baskets, her miniatures and large cooking baskets. Above the cases was a lifesize photograph of her gathering willows. She looked at the baskets. "They all got a story," she told the curator. "Just say 'hi' to them. Wish them well."

"Our prayers worked," Violet said to me over the phone. "She'll be able to make the Strawberry Festival. She can bless the dinner again. She's gonna be all right. I knew there was a reason to put it off a few weeks."

I told Violet I would drive from Stanford to Rumsey to get Mabel for the festival. The plan was that Frances would join us, but something happened, at least that's how Mabel put it, so that Frances couldn't come along. Probably some entanglement around the bingo hall. So Mabel and I started off by ourselves. We drove south on Interstate 80, and then west through Napa instead of going over the hills into Lake County. Mabel wanted to stop in Santa Rosa, where there were more stores and better strawberries.

She was thin, but she looked well, alert. She wore a new dark blue dress, her hair was curled and combed. A black patent leather purse sat on her lap. I had a tape recorder on my lap. I wanted to use my time traveling to Kashaya with Mabel to firm up information for her book. Little had been

accomplished on that project over the last few months, during Mabel's period of ill health and all my trips back and forth with Violet. As we passed over the Napa River on Highway 12, I thought of Mollie, Sarah's mother, Mabel's great-grandmother, who fled the Napa Valley after the Mexicans leveled her village. She went north, into Lake County, and settled in Lolsel, where she married Old Taylor, the medicine man with a floor-length cape of white eagle feathers.

I clicked on the tape recorder and asked Mabel about Mollie. She told stories I had already heard. I summarized for Mabel what I knew about Mollie, what she had already told me time and time again, so she might not further repeat things. "What else do you know?" I asked.

She turned in her seat, leaning toward me, as if to tell a secret. "I didn't know her," she whispered matter-of-factly.

Obviously Mabel could not have *known* Mollie, who had passed away even before Daisy, Mabel's mother, was born. Mabel knew that I knew that. Another joke on me? I pressed on. "Well, Daisy must've heard things from Sarah, and Sarah must've talked to you about her. Sarah would remember her. Mollie was Sarah's mother! I mean Mollie was adopted in at Lolsel, she made beautiful baskets, and married Old Taylor. What else?"

I downshifted to make a turn in the road and the tape recorder flip-flopped in my lap.

"Here, I'll take this," Mabel said, irritated, grabbing the recorder.

I thought she would give it back when the road straightened, but she didn't. She set her purse on the floor next to the plastic Kmart shopping bag containing her ceremonial objects for the festival.

"Now," she said, talking into the machine. "Do you have your prayer basket?" She didn't give me time to answer.

"You got to feed that basket. That's what this Strawberry deal is for. Before Essie died she said to carry it on. Strawberry is to dedicate all new things. Acorn in the fall for the harvest. Each time to bless that basket. You be thinking of that."

She was quiet for a long time with the tape recorder just running. Then she started talking about Essie, about how Essie adopted her in at Kashaya, the stories about her first trip there and the incident of the Kashaya woman who stole her bone whistle. Stories I had heard. About how she saved Essie from the man who wanted to kill her in Windsor. And about how she was doctored by Essie after the woman who used red poison powder snuck up and hugged her from behind.

"Why does a person become a poison person?" I asked, stopping for the first light in Santa Rosa. I had long given up on the Mollie-from-Napa business. I wasn't going to get any new stories no matter what Mabel and I talked about.

"Oh, I guess they're mean or lonely or something. They live by themselves a lot. Old times, ancient times, the poison people they lived off by themselves, away from the village."

"How do they get that way?"

"I don't know. Somebody train them, I guess. Somebody see them and know to give that to them. I don't know."

I drove on a while and pulled into the Farmers' Market, a large grocery store across from my old high school.

"One thing," Mabel said. "We don't take nothing from her. No food, candy. Nothing. I used to tell you kids. We afraid of that woman. Leave her alone. Me and Essie, we seen her once uptown and we each thinking to ourselves to leave that lady alone. We walk the other way." Mabel paused, reflective. "Think how she looked at me and Essie, too."

I parked and turned off the engine.

Prayer Basket

"Now how do you shut this off?" Mabel asked, looking at the recorder on her lap.

"Press the button," I said.

I pushed the shopping cart through the market. Mabel walked along with her cane, nodding at bread, cooked chickens, sodas that she wanted me to put in the cart. She picked out several baskets of ripe strawberries and handed them to me. It was a lot of food, but it seemed hardly to make a dent in all the food at Violet's.

We arrived at Kashaya around one o'clock. Violet's trailer home was teeming with people. Already most of the food was prepared and in place on Violet's long dinner table. There were stews, casseroles, vegetables cooked and raw, pies, cakes, tortillas, frybread, meat of all kinds—beef, venison, chicken, duck—and salmon, whitefish, mussels, and clams. There were bowls of acorn mush and plates heaped with freshly fried seaweed. And there were strawberries, strawberries everywhere, bright red everywhere you looked, in silver and plastic bowls, over cakes and pies, on skewers resting in whipped cream.

People visited awhile before the ceremony. I felt awkward meeting so many people I didn't know. Violet introduced me and explained who I was. "Auntie Mabel's boy. His great-great-grandfather was Tom Smith, same one married to our Grandma Rosie. Smith line." I know a lot of people looked with disbelief, seeing my fairish skin and blue eyes. A few remembered me vaguely from my days with the Indian kids in Santa Rosa. I found a seat near the television and kept my eyes on a baseball game a group of youngsters were watching.

Then Mabel called everyone to the table. She was at the head, and she began calling names, lining up people to her

left. I noticed the men she called held handkerchiefs that were elaborately sewn with crescent moons and stars, Essie's Dream designs. The women wore clamshell necklaces with tribal crosses made from abalone pendants and other shells. "Greg," Mabel called. I sheepishly came forward from the back of the crowd.

"Where's your prayer basket? Put it on. It's part of this rule. You never done this before. Now you got to know. Put it on."

I reached in my shirt pocket and pulled out my tiny basket neatly wrapped in tissue paper. The basket is fixed to a small pouch, which has a safety pin sewn into it so that the basket can be attached to clothing. I pinned it to the outside of my shirt and looked back at Mabel. She was still watching me. In one hand, she held a small medicine basket with pink and gold ribbons streaming down; in the other, she held her split elderberry clapper stick. "Get between Eric and Paul," she said. "In front of Paul."

I took my place between Violet's nephew and her husband, and waited until Mabel finished calling people into the line. Then I followed, with the others, as Mabel circled the table four times, praying. "This is a old-time rule," Mabel said in English. She was at the head of the table again. "Essie said to keep this up so we'll be well. So we'll know who we are. It's the rule. That's all. From the spirit. Ooooh!"

"Ooooh!" people answered.

Later, while we were eating, I heard someone mention that Mabel had stood and walked around the table without her cane. I hadn't noticed. "It was a miracle," they said. I listened from the end of the table, where I ate quietly. A few people asked me where I was from, where I was living. Small conversation. Some asked what Indians I still knew in Santa

Rosa. Others said nothing. Anita was her usual humorous self, full of wild stories. Eric, Violet's nephew, a man about twenty-five, once reached across me for a tortilla and said, "Excuse me, cousin."

After dinner, people bantered and gossiped around the table. I took a walk. It was still light outside, twilight. I went to the cemetery. I roamed around the graves, mounds of dirt in rows under the tall redwood trees. Some of the graves were marked with wooden crosses or those little aluminum-and-plastic placards the county provides. I read the names that were carved in the wood or typed on a piece of paper secured under the plastic placard. A lot of Smiths and other names Violet had mentioned. The Smith line. Who knew my grandfather? My great-grandmother? Old Rosie, where are you buried and are you still talking about Emily? On my way out of the cemetery, I saw two graves covered with plastic flowers and surrounded by a wire fence and locked gate. Essie and Sidney. I stopped awhile, then slowly made my way out of the cemetery and along the dirt road through the reservation.

There used to be a large apple orchard between the Roundhouse and the cemetery. Now people had parked dou-blewide trailers where the trees grew. You can still find an occasional unkempt apple tree here and there among the trailer homes. When I was a kid the trees were pruned each fall and were weighted down with apples every summer. I would go up with the Indian kids I knew in Santa Rosa and their families, a lot of people who, as it turns out, come from Tom Smith also. We'd go up during the festivals, not to par-ticipate, but to hang out. We camped under the apple trees, pitched tents. At night we drank beer and smoked dope, watched the girls. I made sure Mabel didn't see me.

Prayer Basket

Essie used to have a summer festival, the Fourth of July
Festival, where the dances were performed outside in what is
called a Brush House, an open, temporary space cleared and
enclosed by a wall of redwood branches. If you didn't go
inside the Brush House, you could watch the dances from the
apple orchard, or, if you wanted to get closer, you could sit
on top of a car and watch over the brush fence.

Once I saw Mabel dance with Essie. Essie was speaking in
a trance and began a song that her singers picked up. By this
time the Kashaya tribe had split in two, over half the people
leaving Essie for the Mormon religion. There was a lot of
tension on the reservation then, I remember. Essie stepped
forward, almost to the fire, and raised her hands to the sky.
As she came around the fire, her glasses fell. A young girl
darted forth to retrieve them so Essie wouldn't trip. I remem-
ber all this—I was sitting on a car—because then Mabel
stood up, from somewhere in the crowd, and made a long
calling sound. "Ooooooooo . . . ," she hollered. And then she
met Essie. She raised her hands so her palms matched Essie's,
and like that they began to move all around, their long cere-
monial dresses blowing around their bare feet, their hands
locked above them. I knew it was some kind of ceremony,
but I wondered what it was they were doing.

That evening, after I left the cemetery, I ambled along
until I came to the Roundhouse. A rusted chainlink and pad-
lock secured the door. The sideboards of the large round
building were rotted. Winds had ripped shingles from the
roof beams. About fifty yards from the Roundhouse is the
place where they used to build the Brush House each sum-
mer. Now, sand, rusted pipes, mattress springs, and a junked
car covered the spot. So much time had passed, I thought. So
much time since I sat, a bombed-out kid on the hood of a car,

looking over the fence at two women dancing. Once, a year or two after Essie passed away, I accompanied Mabel to the Strawberry Festival. At that time, enough people still attended the event so it was held, as always, on the picnic grounds behind the old schoolhouse, not in Violet's home. I felt uncomfortable, alone then, perhaps more so than when I was a kid. At least when I was a kid I had a lot of people to hang out with, Indian people I knew well. I wasn't a college person so disconnected to everyone around me, except Mabel.

I stood thinking of these things a long while. Then I took hold of my basket, still pinned to my shirt, and started back to Violet's place.

During the summer, I took several trips to see Mabel. We ate at her favorite place, Happy Steak in Woodland. Senior special: fried chicken dinner and salad bar. She always ordered the same thing. Her health seemed to have leveled out—it wasn't better, it wasn't worse. She used her cane for flat, even surfaces; for steps, she used the railing or someone's arm. She moved slowly. I tried to learn more from her, new stories, a way to structure her book, but all she offered were the same stories and the same answers. Stories about her and Sarah. Stories about her and Essie. "Do it the best way you know how," she said, "what you know from me." I remember once I asked her if she ever thought of what Lolsel must've been like before the white people. She laughed. "Why do I want to do that?" she asked.

"You know, to think about the people, what things were like before everything got messed up. I mean, look, Mabel, you're the only one left."

Prayer Basket

"No," she said, shaking her head. "It's the same. It's right here. It goes on."

She was able to weave an hour or so each day and she would teach. She taught another class in Davis and one in Sacramento. Then I heard she canceled both her classes. "Her hands are hurting her too much," Frances said. "She can't even hold the phone to talk to you, Greg." That was in late August. Violet went to spend a week with her. "I want to see what's going on," Violet said. Paul, her husband, dropped her off. He had finally got his car fixed. I offered to drive Violet home at the end of the visit. I also wanted to know what was going on.

"She's hurting," Violet told me after I had arrived at Mabel's.

I was outside, in the front of the house, planting a rosebush in the dry, hard ground. Mabel loved roses, and not much of anything blooming grew around her reservation home. I had picked up the rosebush in Palo Alto, at a garden sale outside the Safeway, where I had stopped to get groceries for Mabel. I always brought her buttermilk and sweet white onions, two of her favorite things, and whatever else I thought she needed, canned soups, vegetables.

"What do you think?" I asked Violet as I dug with the shovel.

"I don't know. Frances stays with her all the time . . . I feel terrible. Mom always said to take care of her. I tried up at home, but . . ."

"Don't think about it," I said. Beads of perspiration showed over Violet's nose and on her forehead.

"Go in," I said, "it's too hot out here."

No sooner had Violet gone in than Frances had come out.

"I don't know what to do," Frances said. "She's back in the

wheelchair and I can't always lift her. I'm nearly seventy years old. Sometimes my grandson, Bill, is here to help, but not always."

"What does Marshall say?"

"He don't know what to do either." Frances ran her fingers through her hair.

"Does she sing her songs?"

"Yeah, but she can't doctor no more. Now she can't weave. I don't know what to do . . . I just worry that she's gonna fall or something. People's gonna say I didn't take care of her."

"No, Frances, don't think that," I said. "You're doing everything for her."

"But I don't know what to do," Frances said, turning back to the house.

I didn't know what to do either, which is something I couldn't say out loud, or even silently to myself. I dug furiously at the tough earth and planted the rosebush. I planted it a few yards from the house, between the front porch and the mailbox on the road. My idea was that Mabel could take the hose and water it. It would be good for her. She could walk from the porch. But now that wasn't going to happen. She couldn't walk. I couldn't think about it. I squatted on my haunches, resting. I looked over at the mailbox with the name McKay over the tin in black letters. Then I looked back at the rosebush full of deep red blossoms.

Not long after that, Mabel rallied. Amazingly, she made it to the fall Acorn Ceremony at Kashaya. She came with Frances and Bill. She was walking, slowly, unsteadily. She performed the ceremony; she called each of us into line and we followed her around the table four times as she prayed. Again she went around the table without her cane. But then she did something unusual. She left her medicine basket and

clapper stick on the table, where people could see them during the meal. She didn't put them away, out of sight, after the procession around the table, as she always had before. "She wanted us to see that," Violet said later that night after Mabel left. Tears rolled from Violet's face. "She wants us to remember her."

I tried to keep in close touch with Mabel after that. I called her at least once a week. But I didn't see her that much. I didn't get to Rumsey very often over the next six months, because I was working madly to finish my dissertation by spring so I could graduate in June. June 1989.

My dissertation did not turn out to be Mabel's book, her life story. Instead it was an academic book about American Indian autobiography. I figured I would finish her book later. I still didn't know how to write her stories. There seemed to be an answer, but I couldn't put my finger on it. I had stacks of information, early government census rolls on California Indians, endless ethnographic data on the Pomo and Southwestern Wintun Indians, several interviews with the museum curators and basket specialists who had known Mabel over the years, articles and newspaper clippings. Two passages seemed particularly meaningful to me, and I pinned them over the desk where I worked. The first was from "Western Pomo and Northeastern Pomo," an article printed in the *Handbook of North American Indians* and written by ethnographers Lowell Bean and Dorothy Theodoratus.

Since personal relationships among the Pomo were based primarily on kinship, relationships with nonkin were tenuous and suspect. However, a special, fictive kinlike relationship, loosely translated as "special friend" could be established between two individuals. This was a formal relationship

involving a ritual gift exchange, which contracted a reciprocal relationship, sometimes for the lifetime of the partners, and tacitly included the primary relatives of each of the partners.

The second passage was from the recorded words of Tom Johnson, a Pomo elder from Lake County. He had been recorded in 1976, and the text was published by Bruce Levene in *Mendocino County Remembered: An Oral History,* and later reprinted by Victoria Kaplan in *Sheemi Ke Janu (Talk from the Past), A History of the Russian River Pomo of Mendocino County.*

> What is a man? A man is nothing. Without his family he is of less importance than that bug crossing the trail, of less importance than spit or dung. At least they can be used to poison a man. A man must be with his family to amount to anything with us. If he had nobody else to help him the first trouble he got into he would be killed by his enemies because there would be no relatives to help him fight the poison of the other group. No woman would marry him because her family would not let her marry a man with no family. Without the family we are nothing, and in the old days before the white people came the family was given the first consideration by anyone who was about to do anything at all.

I finished my dissertation on time and planned a big graduation party. Everyone was to come: my Indian family, Violet and Paul, Anita, and all the folks I knew at Kashaya; my Filipino family, Grandpa Hilario and all the relatives I had met during the last few years; Mary Sarris and her clan; Howard Hartman, my natural mother's brother, and my grandmother (if she would come); Marshall McKay and his family; Mabel and Frances. Mary Sarris helped me with the details. She

wrote out invitations and planned the food. "It's unbeliev-
able," she said. We were sitting at her kitchen table with a
stack of addressed envelopes between us. Nearly four hun-
dred people were invited. So many people who didn't know
one another. People who had met only in my blood.

"I know, a lot of people," I said.

"Yes," she said, "but your whole story."

"You're part of it, Mom," I said. I wanted to assure her that
she need not feel guilty about the hard times in the past or
feel threatened by my newly found family. She had endured
an abusive husband; she was Catholic and she put up with
the marriage for as long as she could. Times were different, I
always reminded her. And to protect me, she did the best she
could. She took the best, or the only option, she figured she
had. She let me roam, live here and there, and I always told
her I was all right. And now she was meeting my new family
and handling the situation gracefully, welcoming each new
face with open arms. Her life had not been easy. A well-to-do
girl who wasn't prepared for the knocks life dealt her. A
lousy husband, financial difficulties, the deaths of two of her
three children. Patrick, who was seven months younger than
me, from leukemia, and Maryanne, her daughter, from a
madman's bullet through her head. Only Stephen was left.
She held up well, became strong against the storm. She
looked neat, perfect, as if she was ready to be photographed
for the cover of *Good Housekeeping*. Her modest home was
spotless. It wasn't a matter of being shallow or living in
denial; it had to do with doing the best you can with what
you've got.

"You've got a story too, Mom," I said.

For the first time in ages, I saw her eyes fill with tears.

The acceptances rolled in. Everyone planned to attend

Prayer Basket

the party. Except for my natural grandmother, which didn't surprise me. The woman with the girl-falling-off-the-horse story. Why would she want to face the truth, see her story reflected back in four hundred pairs of eyes? Each person or family noted on the reply card how many would attend. On Mabel's card, Frances wrote "three"—Mabel, Frances, and Bill, who would drive them. Mabel was walking, still getting about at the same pace, though the arthritis in her hands prevented her from weaving. I was happy she was going to come to the party. As it turned out, though, she didn't make it.

Violet once told me that Indian doctors have lines around their bodies, spirit lines, sometimes four, sometimes more. The lines are sources of power and strength for the doctors. They are protected by them. When a doctor gets old, when he or she doesn't exercise those lines, the lines weaken and pain, sickness, and poison can enter there. The lines snap, break, which is what Mabel must've felt that early May morning after she had gotten out of bed. She went down, just dropped to the floor, as if she had been let go, torn away from all that had held her up.

It wasn't as if she hadn't given us signs. "It's catching up with me," she said, showing me her swollen wrists a year and a half before, at the Happy Steak after our trip from Stanford. Her leaving the medicine basket and clapper on the table at the Acorn Ceremony. Her missing the Strawberry Festival just two weeks ago, the first ceremony she had missed since Essie took her in at Kashaya. Violet prayed, led us around the table as best as she could.

When I got to the hospital, I found her full of tubes. A doctor came into the room and told me she had suffered a major stroke. "And when she fell, she broke her hip," he said.

Prayer Basket

"We didn't set the hip because we don't expect her to pull out of this." He was straightforward, honest. He asked if I had any questions, then left.

I joined the others outside in the hallway. Violet and Paul were there. Anita. Vana, Violet's younger sister. Marshall. Frances and Bill. "She just went down," Bill said, repeating the story he had told me when he first telephoned with the news. "I heard her, this crash, and found her on the floor." His young round face was pale, colorless. "It's good you were there," I said. "You helped get her to the hospital."

We kept watch all night. We prayed. She wasn't expected to make it to the morning. We prayed. We kept watch four more days, four more nights, and for two weeks after that, we took turns sitting by her bed. They took the tubes out of her nose. She held on, had no difficulty breathing on her own. She opened her eyes and began to look around. She surprised the doctors. Though she was very weak, unable to talk, unable to use one side of her body, she pulled through.

The hospital in Woodland moved her to a nearby nursing home, a huge, impersonal institution, one hundred and fifty beds. She was referred to as "the Mexican lady in 103" by one nurse. Another nurse thought she was Filipino. "We don't get much time with the patients," this last nurse said after I told her that Mabel was American Indian. I quickly made arrangements to have Mabel transferred to Friends House, a twenty-five-bed nursing facility in Santa Rosa run by the Quakers, where Mabel would get the best possible care. Mary Sarris's mother was living there, and after I explained to the staff in charge who Mabel was and the situation, they were kind enough to make room and take her in.

That was at the end of May. Two weeks later I graduated. The yard behind my little cottage was filled with people.

Prayer Basket

Friends were there. Faculty. And family. Lots of family. Jews. Catholics. Filipinos. Mexicans. Indians. Violet. Anita and her children. Violet's middle sister, Vivien, and her children. Marshall and his family. Grandpa Hilario and his niece Amparo and her children and their children. My Indian grandmother's sister's daughter, Marguerite, and her daughter, Velia, and her daughter and son from Los Angeles. Mary and her brother Vance and his family, her sister Joan and her family, and her brother Jack's family. Mary's son, my brother Steve. Howard Hartman. On and on. Abundant food. Congratulations. I gave a brief talk. Something about family and how we were all related. I said I thought my mother, Bunny, and my father, Emilio, would be proud. So would Mabel. She had always been there along the way for me. I missed her.

Not long after I graduated, I moved to Berkeley, where I would write and study for a year. I found a quiet place in the hills above the campus. I finally had an opportunity to catch my breath, slow down. I spent time at Friends House with Mabel. She improved significantly. She could sit up in a wheelchair. Doctors had operated on her hip so she could sit comfortably. She couldn't walk, or even try, because one side of her body remained paralyzed. One side of her face slanted, her mouth turned down in one corner. Still, she seemed alert, and she talked, slowly, slurring her words. But if you listened closely, you could understand her.

She made quite an impression on the nurses and other patients. Mabel's roommate was a young woman who had been in a cast for months. She had broken her leg in several places and the bones were not mending. One night the woman was crying. She and Mabel were in their room in their wheelchairs. Mabel gestured with her one good arm for the woman to wheel herself over. The woman did, and Mabel moved her

hand up and over the woman's cast. A week later, X rays showed the woman's bones were mending. A new patient, an elderly woman diagnosed with Alzheimer's disease, screamed incessantly. They confined her to her room, door closed. "She wants a baby," Mabel said. "Give her a doll." They gave the woman a small Raggedy Ann and she stopped screaming. "She's brought a lot of life around here," a nurse told me.

I wheeled her outside on the warm summer mornings. She gestured with a straight hand when she wanted me to stop. She rolled her hand when she wanted me to continue on. We stopped often in the rose garden behind the facility. There were lots of other flowers there too, dahlias, marigolds, pansies, and petunias. Two large valley oaks grew by the back fence. We rested in the shade there. I lit her cigarettes for her and she smoked. *"Cisq qhale,"* I said once looking up at the oaks. I was sitting on a wooden bench next to her wheelchair. "What?" she asked, seemingly confused by what I said.

"Cisq qhale," I repeated. "The Kashaya word for oak tree. Well, tan oak. But just the same, it sounds good even for this valley oak. *Cisq qhale* means 'beautiful tree.' "

"Hmm," Mabel said, blowing out a cloud of smoke. She looked up to the trees. "Good crop coming."

I looked, squinted, then saw camouflaged among the green leaves the tiny green acorns. Thousands of them.

I kept thinking about the book. I knew enough not to bother Mabel with my questions. She could talk, answer questions if asked, but any kind of extended conversation was difficult for her. She could speak only from one side of her mouth and she tired easily. Besides, even if she could talk to me as she always had, wouldn't she give me the same answers, tell me the same stories?

Prayer Basket

Marshall called and told me he had found some old pic-
tures while sorting through Mabel's boxes. He thought
maybe we could identify some of the faces in them. We
couldn't, not very well. They were old black-and-whites, da-
guerreotypes from the turn of the century, the teens, and the
twenties. Indians in heavy clothing in front of barns, shacks.
Some on front porches of small ranch houses. In one photo-
graph, several people were in ceremonial dress in front of an
old-style Roundhouse, a Roundhouse that was largely under-
ground, only its roof and entrance showing above ground.
The men wore elaborate headdresses and feather skirts over
trousers rolled up to just above the knee. The women, lined
up on either side of the men, wore long, late-nineteenth-
century–style dresses and held scarves between their hands.
"Probably Cortina," I said.

We found a picture of Mabel as a young girl, dark and
malnourished-looking, standing beside an older woman,
probably Grandma Sarah. The woman looked worn, tired,
though she stood square and strong in her baggy coat and
long dress. She wore a scarf tied over her head. There was a
picture of Mabel at about the same age alongside a younger
woman holding a baby in a cradle woven with willow rods.
Probably Daisy, Mabel's mother, with her daughter from
Andy Mitchell in Colusa, who later passed away. And there
was one of Mabel at a later age, probably in her mid or late
twenties, standing behind the older woman seated in a chair.
Mabel's hair was curled; she looked neat in clean clothes and
trim. But the people in the other photographs, the Indians
on porches, in front of barns, in ceremonial dress, remained
nameless.

"Sometime we'll have to ask Mabel," I said to Marshall.
"She'll know." We were sitting at Mabel's kitchen table in

her house on the Rumsey Reservation. After working with the tribe to settle the squabbles over the bingo hall's management and moneys, Marshall had been elected treasurer of the Rumsey Wintun. He spent a lot of time on the reservation. He stayed at Mabel's house. Hah, I thought to myself that morning, he did need this house, just as Mabel once said he would.

"It seems strange without her here," I said, looking at her ashtray on the table.

Marshall sat back in his chair and laughed. "You know what she would say to that."

"Yeah," I said. "She'd say, 'I'm here. I didn't go nowhere.'"

"Right."

Marshall put the pictures away. We never got to ask Mabel about them. A couple of months later, in September or early October, she suffered a series of strokes that left her speechless. She could no longer sit up for any length of time in her wheelchair. She spent more and more time in her bed, sleeping. "She stayed in her Dream," Violet said, "where she always was."

A week after I had looked over the old photographs with Marshall, I visited Violet at Kashaya. I visited her often. We talked a lot about my family history. Our family history, actually. She told stories about Grandpa Tom Smith and many of the people Essie and Grandma Rosie knew. I told her stories about the Indians I knew while growing up in Santa Rosa, Indians from Kashaya and lots of other places, Ukiah, Healdsburg, and Lake County, a lot of Indians whom she didn't know. Our stories mixed and overlapped, this person knew that person, was married to this uncle, that aunt. She insisted I call her Auntie, in the Indian way for any female

relative, no matter how you are related, who is a generation or more older than you. It felt right.

We were sitting at her table, talking. It was late, about three in the morning. I was drowsy, even after five cups of coffee during the last few hours. She was talking about her mother and Mabel. Essie and Mabel, some story I had heard before. Then there was a jump in the story line. I hadn't followed or I'd been asleep, because then she was saying something about me, my coming to Kashaya. I barely caught it.

"What?" I asked.

"Mabel," Violet said, emphasizing the name to make sure she had my full attention. "Mabel said you would come here. Seven or ten years ago. A while ago. When you weren't around here. Before you knew us. She described you, told us you would come and to take you in. It was her prophecy, her Dream. That's why Anita and I looked at you so closely when we first met you. Is he the one? we asked each other. Then I asked Aunt Mabel and she said yes." I thought of that first drive down the mountain with Violet and Anita, and I remembered them talking in Kashaya about me and Mabel. I tried to picture Mabel telling them about me. I heard her. *He will come here. You take him in.* As if she were talking to me. I heard her. Not just words. Not just stories.

I sat back in my chair. I felt my feet on the ground. I saw clearly. Things came together. It wasn't just her story she had wanted me to know. While trying to help her, while trying to trace her story, I traced my own. I had pretty much sensed this. But it was more than that even. It was a blessing, a miracle. Hers was a life that gave, a life only in the Dream. I had never known her any other way. How else could I write her book? How else but from the Dream, what I knew from her? Her story, the story, our story. Like the tiny basket in my

shirt pocket, different threads, sedge and redbud, woven over
one willow rod into a design that went round and round, endless.

"Why didn't she tell me?" I asked.

"Because," Violet said, "you wouldn't believe. You had to wait and see how it turned out. You learned you're Indian, part of us here. You know Indians. You know stories and history. You'll learn more. But, for us, it's always about Mom and Aunt Mabel. It's about the Dream."

The next day I drove straight from Kashaya to Friends House. I found Mabel alone in her room. She was slumped in her chair, sleeping. I woke her. I went on about everything I had learned from the night before. I thanked her and thanked her. She listened, then rolled her hand.

I wheeled her outside. We went past the marigolds and pansies and stopped at the roses. My mind wouldn't stop spinning.

"Why me?" I asked, moving around to the front of the wheelchair. "Why did you do it for me?"

I squatted in front of her and repeated my questions. "Why did you do it for me? Why'd you do so much for me? Why me?"

She looked me in the eye and said, plain as day, "Because you kept coming back."

Prayer Basket

On May 31, 1993, Mabel McKay passed away. She was buried on June 4 next to Essie Parrish in the Kashaya Pomo cemetery. It rained and thundered.